CAPE COD'S
O L D E S T
SHIPWRECK

CAPE COD'S
O L D E S T
SHIPWRECK

THE DESPERATE CROSSING OF
THE *SPARROW-HAWK*

MARK C. WILKINS

Charleston | London

THE
History
PRESS

Published by The History Press
Charleston, SC 29403
www.historypress.net

Back cover image courtesy of the Pilgrim Hall Museum.

First published 2011

Manufactured in the United States

ISBN 978.1.59629.860.6

Library of Congress Cataloging-in-Publication Data

Wilkins, Mark C.
Cape Cod's oldest shipwreck : the desperate crossing of the Sparrow-Hawk / Mark C.
Wilkins.
p. cm.
Includes bibliographical references.
ISBN 978-1-59629-860-6
1. Sparrow-Hawk (Ship) 2. Shipwrecks--Massachusetts--Cape Cod. 3. Cape Cod (Mass.)--
Antiquities. I. Title.
G530.S76W55 2011
910.9163'46--dc22
2011013955

Notice: The information in this book is true and complete to the best of our knowledge. It is offered without guarantee on the part of the author or The History Press. The author and The History Press disclaim all liability in connection with the use of this book.

CONTENTS

ACKNOWLEDGEMENTS

I would like to thank the following institutions for their assistance with this project: Pilgrim Hall Museum; Plimoth Plantation; the Jamestown-Yorktown Foundation; the British Library; the National Archives at Kew Gardens, United Kingdom; the Public Records Office, United Kingdom; the Virginia Historical Society; and the Massachusetts Historical Society. I would like to extend my sincerest thanks to the following individuals for their help with this book: Stephen O'Neill, Karin Goldstein and Peter Arenstam, and a very special thanks to Karin Hobman.

INTRODUCTION

Euopean expansionism during the sixteenth and seventeenth centuries was a dynamic period in Atlantic—and world—history, the result of which was a transformation for England from the periphery of trade and influence to the center. By the end of the first quarter of the seventeenth century, British imperialism and nationalism were no longer just nascent ideologies alluded to in writings by Richard Hakluyt, John Dee and others. Importantly, by the conclusion of the sixteenth century, the woolen trade— on which England had depended for its economic vitality—was clearly depressed, and to survive it needed to find new markets and commodities to reinfuse a sagging economy. Britain had also won its elemental struggle against Catholicism, giving birth to an umbrella Protestantism, as well as the Church of England. This transformative experience served to create ultra-radicalized factions, such as the Separatists, which, dissatisfied with that which was acceptable to a majority of the inhabitants of England, sought their utopian societies first in Holland and then on the faraway shores of America. The Pilgrims intended to build a model society to serve as an example to England of how the Reformation should have concluded. They would not equivocate or settle for an umbrella Protestantism; rather, they would forge a unique Protestant dogma that was strict, uncompromising and free from the episcopacy that seemed to perennially plague religious doctrine back in England.

However, religious freedom was not the only motivation for contemplating a voyage across the pond. America also held the promise

of new commodities and, consequently, new fortunes to be made. By the end of the first quarter of the seventeenth century, economic prosperity in the form of fragrant bundles of Virginia tobacco had begun to make an impact in London—and elsewhere. Merchant joint-stock companies began to materialize with increasing frequency as merchant coalitions dreamed of expansive tracts of land, dense with tobacco growing in the warm Virginia sunshine. No doubt, dreams of vast fortunes amassed from tobacco monopolies encircled and intoxicated the heads of these adventurers just as surely as the smoky exhalations from the object of their quest. In addition to fortunes made from tobacco, voyagers to America undoubtedly contemplated freedom from the oppressive class structures, poor economy, plagues and the very finite lands of England. In turn, the Crown saw the colonial projects as a way to rid England of unwanted or surplus populations who were flocking to London, caught in its gravitational pull of commercial vitality.

The voyagers aboard the small vessel that would come to be called the *Sparrow-Hawk* were such people. They also possessed a spirit of almost reckless adventure and an insatiable desire for something different and new, without which the birth of the United States never would have been possible. Moreover, the story of the *Sparrow-Hawk* did not end when she was shipwrecked in 1626–27, as her reemergence during the Civil War sparked another period of confused and somewhat problematic interpretation concerning the oldest extant shipwreck in America. Her ultimate home would be, paradoxically and ironically, the institution that represented those who expelled the crew of the *Sparrow-Hawk* from Plymouth some 384 years ago.

My obsession with her tired and enigmatic bones began when, as curator of a small maritime museum on Cape Cod, I was invited by my friend and colleague Stephen O'Neill, curator of Pilgrim Hall Museum, to visit this anachronism. As I gazed upon her time-worn bones, it was as if I was once again seven years old and beholding my first dinosaur skeleton—the strange logic of her ribs and structure evoking a creature long departed yet exciting my imagination as to how it might have looked long ago, plowing along across the vast expanse of a wintry and windswept North Atlantic. I then worked with the Pilgrim Hall Museum to bring her back to the Cape for an exhibit on the seventeenth century. It is the aim of this book to finally give the *Sparrow-Hawk* and the brave, perhaps foolhardy, people who sailed on her their long-awaited due. Her story is not as morally uplifting as that of the Separatists (or Pilgrims, as they have come to be called), but it is

valid, for implicit in this tale is one of the essential qualities of American economics and ethos—that of venture capitalism, entrepreneurial acumen, religiosity and a desire for a better life just a little farther westward. Her story and what this voyage represented does not fit neatly within many American historiographies of the early to mid-twentieth century, which preferred to depict the Pilgrims and those at Jamestown as distinctly different types of people. The passengers and crew of the *Sparrow-Hawk* were somewhat pious but also somewhat entrepreneurial; some were not chaste. Undoubtedly, there were many such voyages, which would tend to further diversify the nature of colonists during the Great Migration of the 1620s and 1630s. Even today, the tired bones of the *Sparrow-Hawk* remain a somewhat enigmatic anomaly that creates dissidence and arouses curiosity regarding the origins of this country. This is her story.

1

LONDON AND JAMESTOWN DURING THE 1620S

From the last quarter of the sixteenth century to the year the *Sparrow-Hawk* sailed (1626), London grew from a disease-infested city on the verge of economic collapse to the beginnings of a mercantile hub as the promise of economic prosperity began entering its ports in the form of bundles of tobacco from Virginia; fish from New England; sugar from the West Indies; wines, currants and raisins from Spain, Portugal and the Mediterranean; and silks, spices and pepper from China. Most of the demand for these products came from an increasingly consumptive London populace. Interestingly and importantly, both sugar and tobacco were addictive substances, and Queen Elizabeth I apparently liked sugar so much that it turned her teeth black.

During the first half of the seventeenth century, England's population increased by 24 percent, while London's population grew by 88 percent—even with high mortality rates.[1] London was also becoming a focal point for domestic trade as merchants set up shops to take advantage of its port status. England's reformation was at a close, but England was broke due to its long, protracted war with Spain, compelling James I and IV (of England and Scotland, respectively) to end it in 1603. In 1604, the woolen trade, on which England had always depended for economic stability, was clearly depressed. By as late as 1616, woolens still constituted about 80 percent of England's exports,[2] forcing England to look to the sea and the faraway shores of America for an answer to its dilemma. In addition, in an effort to broaden the appeal of England's chief export, foreigners flocked to London to help develop a lighter, more versatile version of the traditionally heavy English woolens (old draperies).[3] "New

draperies," being lighter, appealed to a broader audience and were also ideally suited to warmer climates. English woolens, be they heavy or light, were sent to Antwerp to be finished and dyed until about 1580. Political, commercial and religious upheaval closed Antwerp to English woolens producers and forced them to export their fabrics to German and Baltic ports; as a result, volume fell by about 20 percent.[4] Still, England needed new commodities with which to build a more diversified and subsequently more stable economy.

Interestingly, England saw its expansionism as a distinctly westward phenomenon, a trait that Americans would inherit and further, as witnessed by the final annexation of California to the Union in 1850. More interesting still is the symmetry and irony of this ambition. As England experienced gold fever in the sixteenth and early seventeenth centuries (royal colonial charters included explicit instructions for obtaining gold and silver above all else), America (California) would follow in the 1850s.

The London of the early seventeenth century was teeming with activity and was in a perpetual state of consolidation and expansion. It was at the

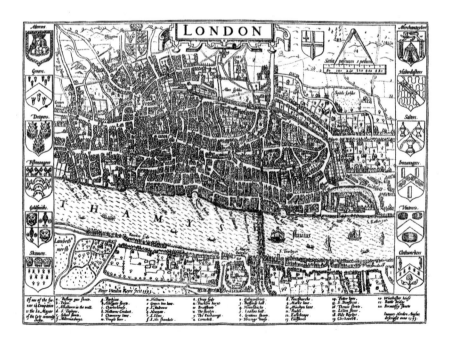

John Worden's map of London; note the trade guilds on the left and right margins. This map not only provided a semi-accurate map of London, but it also let all who viewed it know that London was a commercial hub—not only for foreign imports but for domestic products as well.

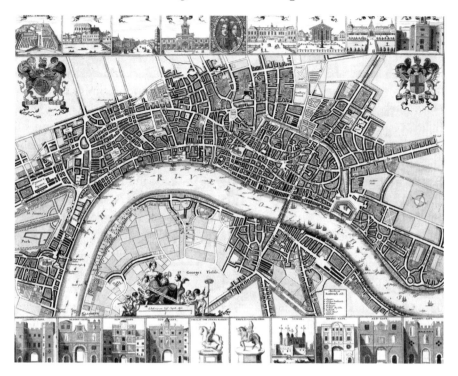

Antique map of London by Braun & Hogenberg, 1572–1624. This map focused
on architectural highlights of the city, as well as its multitude of gates. Note the wall
(punctuated by the various gates) starting at the tower and encircling St. Paul's Cathedral.
Interestingly, all of the structures contained in this map are of masonry, underscoring the
idea that (some of) London was permanent (impervious to fires).

center of mercantilist and colonial projects. Businesses opened, ran their
course and failed; those that prospered grew. The food and drink business
was especially lucrative, and one out of every twenty houses in London
was used as a tavern.[5] Cheap and often illegal (tenement) housing was built
at a rapid pace and clogged the already crowded streets of London.[6] Due
to the Reformation, the Crown was able to seize land on which Catholic
monasteries had been built. These became new London suburbs, with houses
and streets to accommodate the never-ending stream of people coming to
London. This became so expansive that James I ordered a ban in 1607,
stating that there should be no new building within two miles of the gates
of London, except on old foundations or in the courtyard of an existing
home.[7] Paradoxically, the Crown repeatedly undermined its own authority
by selling licenses to build illegal buildings and then allowing offenders to
keep these buildings for a fee.[8] These monies were used to generate revenue

for the perennially empty royal coffers—a problem that would climax with the reign of Charles I.

Another noteworthy business was the printing house, as there was much to print. Mortality sheets, Shakespeare's folios, Captain John Smith's *Generalle Historie* and other accounts of exploratory efforts in the Americas and West Indies began to circulate all over London. This was also the London of Shakespeare and the Globe Theater, of "publicke" houses where one might find a diverse cross section of Englishmen, Irishmen and Scots, plus many foreigners from the continent—from gentry discussing the latest edicts of James I and vagrants hoping for a handout to mariners and adventurers planning their next venture in the Atlantic world, shipbuilders and port officials. The king and court were completely separate but omnipresent entities, and daily life at court included all attendant sycophants and entrepreneurs hoping to gain favorable trade conditions or earn a place at Windsor Castle. As commerce in London grew, so did the infrastructure for the port, and shipbuilding and associated trades started popping up downriver in such hamlets as Wapping, Shadwell, Limehouse and Poplar. Approximately half the workers in these towns were mariners or people associated with the maritime trades.[9] In addition, there was a seemingly insatiable desire for unskilled laborers to help with the loading and unloading of ships and vessels up and down the Thames.

Moving through the narrow and crowded streets of this burgeoning hub of commerce, politics and influence, one might spy a rather sickly fellow staggering along or leaning against the corner of a hastily constructed tenement, his ashen pallor causing passersby to hasten their pace to avoid lingering near yet another potential plague victim. In 1625 alone, forty thousand people died of bubonic plague.[10] Perhaps the poor unfortunate was only drunk—at the Pope's Head Tavern in Cornhill, wine could be had at a penny a pint, and bread was free.[11] Or for a few more pence, one could satisfy his hunger with a meat or oyster pie, the contents of which were procured from the banks of the Thames, shell and all. After a filling, if not healthy meal, one might shuffle down the filthy cobbles of any number of thoroughfares and streets, the autumn sun setting in the west, casting long purple shadows across the hewn beams and plastered façades of the countless Tudor dwellings lining London's growing business district.

Making one's way down to the center of commercial activity, the Thames, perhaps one would be handed a flyer that documented recent deaths due to the plague or a handbill for a play. Starting in the 1570s, six new theaters were established around London; John Stowe called them "public places." They

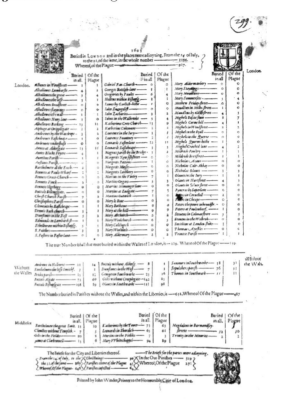

Bill of mortality for London for the week of July 14–21, 1603. *Courtesy of the National Library of Medicine.*

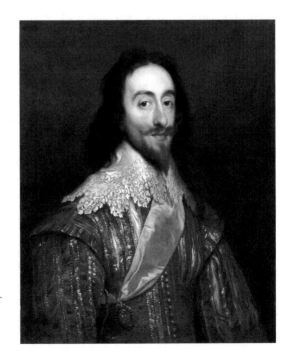

Portrait of King Charles I, painted in 1632 by Daniel Mytens. Charles was educated and cultured and appreciated others of similar disposition. He also had a contentious relationship with Parliament over the issue of royal finance. This resulted in a civil war and would ultimately cost Charles his head.

were round or octagonal in shape and could hold between two and three thousand people each.[12] Theater was the biggest form of entertainment in London, but one could also find amusement in public executions or gambling on cockfights or archery competitions. There were two theater districts. One was in the northern outskirts, in Finsbury and Shoreditch, and the other was across the Thames in Bankside and Southwark.[13] Shakespeare's celebrated Globe Theater was located in Southwark. Theaters were deliberately built outside the jurisdiction of city officials, and actors needed a license or a powerful patron such as Lord Chamberlain or the king in order to avoid the charge of being rogues.[14]

By March 1625, James I was dead and was succeeded by his only son, Charles, who at the ripe old age of twenty-four became Charles I of England. There was a marked difference at court with Charles, who nurtured and appreciated learned and clever men in all disciplines. Banished were the fools, jesters and bawds of his father's court. Charles also was an avid lover of the arts and took a keen interest in paintings, carvings and prints. The young king was serious, temperate and chaste, in strident contrast to the previous monarch.[15] King Charles had a tense relationship with Parliament almost from the very outset. Occurring concurrently with Charles's ascension to the throne was one of the worst outbreaks of the plague (1625). What ensued in the following months was a great debate over how the king would be funded. Traditionally, the king derived revenues from various forms of taxation, most notably customs duties, which were termed "tonnage" and "poundage." In other words, the more commodities that were imported into England, the more the king earned.

By this time, Virginia tobacco had become a lucrative commodity, and much of it was labeled "for the king's personal consumption." (This will be explored in greater detail shortly.) The tonnage and poundage revenue stream was usually granted to the monarch for life, but with Charles, Parliament voted to give him these monies for only one year so it could reconsider the problem of royal finances after the plague had subsided (members of Parliament then bid a hasty retreat from London).[16] The king also derived revenues from other forms of taxation, which Parliament considered illegal. The debate over royal finances and church reform would ultimately cost Charles his head and would plunge England into civil war in the early 1640s. However, during the mid-1620s, Charles was concerned with other ways to fund his Crown while still begrudgingly working with Parliament. With the winds of war brewing between Spain and England again, Charles was about to spend large sums of money on a war, making his need for increased revenue even more profound. To make a very long and tortuous story short, Parliament refused to grant

George Villiers, first duke of Buckingham, 1625. Tinted drawing by Daniel Dumonstier (1574–1646), a French painter and draughtsman. Buckingham had a taste for excess. He threw lavish parties and liked fine things, and Parliament accused him of leading king Charles astray.

Charles the money he requested, so Charles simply dissolved Parliament. After all, the monarchy was by divine appointment. What right did Parliament have to deny the king that which he demanded?

Charles launched an ill-fated naval/army attack on Cadiz, during which the army made a successful assault on a plentiful supply of local wine, rendering its actual attack pointless due to excessive drinking and scarce food. The army was reduced to little more than a drunken rabble! The failed assault force returned to Plymouth in the fall of 1626, tired, sick and dying. Perhaps the crew of *Sparrow-Hawk* saw the men trudging through the streets as they prepared for their voyage.

Back in London, the king was desperately short of money again, forcing him to reluctantly convene Parliament in February 1626. During this kiss-and-make-up session, Parliament laid the blame for the king's poverty squarely at the doorstep of his chief advisor, the duke of Buckingham, who had lavish feasts, stately homes and countless other excesses. Ostensibly, the evil duke had led the good king astray, Parliament equivocated, still not quite ready to confront the king of England with allegations of fiscal impropriety. After the sacrificial bloodletting, as manifested by the impeachment of Buckingham, the king and Parliament reached a temporary accord. But it wouldn't last past June 1626,

when, in a fit of frustration over the dreaded royal finances, Charles dissolved his second Parliament. Outside the rarified environment of Parliament and the court, the public watched with increasing uneasiness, ravaged by plagues, a lackluster economy, ever-increasing numbers of unemployed and seemingly more taxes, plus the contentious relationship between Charles and Parliament unfolding in front of them. The people of London wondered what form salvation might take. For many, even the wild and barbarous lands of America seemed a much more palatable alternative to staying in England. Into this teeming and dynamic economic and sociopolitical context, a pair of English merchants by the name of John Fells and John Sibsey were most likely to be found during the late fall/early winter of 1626. Their goal was simple: secure a charter and find a ship, crew and enough indentured servants and agricultural equipment to start a tobacco plantation in Virginia. The ship they chose would come to be called the *Sparrow-Hawk*. Although this sounded straightforward enough, it was, in fact, a very complex proposition—or was it?

During the second quarter of the seventeenth century, England had begun funneling support to Virginia in the form of supplies, materials, troops and myriad other items necessary to maintain the tenuous toehold England had at

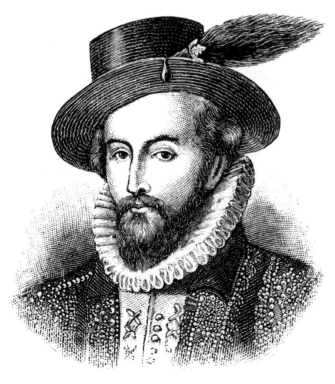

Sir Walter Raleigh. Raleigh and Queen Elizabeth I had dreams of an empire built on the tobacco trade. Raleigh also founded the first colony in America at Roanoke. *From Montgomery's* The Beginner's American History *(1904), page 22.*

Jamestown after the collapse of the Virginia Company in 1624. The Crown did this to ensure the survival of the tobacco trade, which by this time had become lucrative. Although Sir Walter Raleigh founded the first colony in Virginia at Roanoke in 1558—which he used as a base from which to conduct privateering raids against the Spanish gold fleets[17]—this colony ultimately failed. Upon his return to England, Raleigh became an outspoken proponent of a curious leaf that could be smoked and was appearing in England with increasing frequency during the latter portion of the sixteenth century. The first official records of tobacco importation into England appear in 1603, during which sixteen thousand pounds of it were recorded as coming into England.[18] Interestingly, the first appearance of the smoky weed in English literature occurred in Spenser's *Faerie Queene* in 1590, the use of which was described as having medicinal qualities:

> *Into the woods thenceforth in hast she went, To seeke for hearbes, that mote him remedy...There, whether it divine Tobacco were, Or Panachaea, or Polygony, She found, and brought it to her patient deare Who all this while lay bleeding out his hart-bloud neare.*[19]

King James I of England and IV of Scotland, by Daniel Mytens, 1621. James hated tobacco and wrote his *Counter-blaste* condemning the use of this stinky weed. However, James did not mind the revenues tobacco produced, which in turn infused the royal coffers.

Not surprisingly, Elizabeth I and Sir Walter Raleigh were patrons of Spenser. Jerome Brooks, an eminent tobacco historian, wrote that after 1590, England exceeded all other countries in its zeal for tobacco.[20] By 1604, James I had ascended to the throne, and among his many new initiatives was a polemic on the use of tobacco. His *Counter-blaste* was a fiery chronicle of the evils of tobacco, made more so by the fact that at this point most of it had come from England's archenemy—Spain. The following is an excerpt:

> *And for the vanities committed in this filthy custome, is it not both great vanitie and uncleannesse that at the table, a place of respect, of cleannesse, of modestie, meni should not be ashamed to sit tossing of tobacco-pipes, and puffing of the smoke of tobacco, one to another, making the filthy smoke and stinke thereof to exhale athwart the dishes, and infest the aire, when, very often men that abhor it are at the repast? Surely smoke becomes a kitchin farre better than a dining chamber, and yet it makes a kitchin also*

Nicotiana rustica, or tobacco that was indigenous to Virginia.

oftentimes in the inward parts of men, soyling and infesting them with an unctuous and oily kind of soote, as hath been found in great tobacco takers that, after their death, were opened. And not onely meate time, but no other time nor action is exempted from the publicke use of this uncivil tricke.[21]

As the antecedent to and in contrast with the diatribe by James I, others extolled the virtues of *Nicotiana rustica*[22] during the last quarter of the sixteenth century. While England and the Spanish Armada were slugging it out in the English Channel in 1588, Thomas Hariot's (who, not surprisingly, was Sir Walter Raleigh's servant) *A Briefe and True Report of the New Found Land of Virginia* promoted Virginia as a good investment while simultaneously extolling the medicinal virtues of tobacco. Hariot suggested to potential investors that, in order that Jamestown "may return you profit and gain," a miraculous Virginian herb would come in very handy.[23] Tobacco was also, at this time, being planted on English soil; both William Harrison and the elder Richard Hakluyt, writing in 1573 and 1582, respectively, praised the nutritional and medicinal qualities of tobacco, stating that it helped to ease the rheum.[24] The rheum was the chronic cold or allergic reaction that seemingly sprung from living in damp and chilly Tudor England. By the end of the sixteenth century, with the English woolen trade in marked decline, colonial projects became a necessity, first in Ireland and then in America. All of England had high, if not desperate, hopes for new commodities that would infuse its sagging economy.

The Virginia Company, a merchant coalition given a royal charter in 1606, founded a colony in Virginia that experienced a difficult and problematic first several years. Jamestown was founded in 1607 and was initially characterized by a miserable struggle for survival on the part of the colonists. The mortality rate was high, and their charter had instructed the colonists to immediately begin searching for gold, silver or other commodities that would turn a profit, emulating the Spanish model of importing precious metals, which had made Spain rich. Little consideration was given to how the colonists would interface with the indigenous peoples and environment, resulting in the colony's limping along, searching for gold and silver while nearly starving to death. Jamestown nearly failed; however, the Virginia Company, which had the support of the Crown, was desperate for new commodities and poured untold human and material resources into this little fort near the confluence of the James and York Rivers.

The savior of Jamestown was tobacco. Without this addictive and lucrative crop, the Jamestown colony most assuredly would have vanished

like the ill-fated Roanoke colony. Indigenous Virginia tobacco had a bitter taste, which many Englishmen believed indicated poor quality—especially when compared to the sweeter Spanish tobacco, which was being cultivated in the West Indies and was duly being imported into England. However, when John Rolfe imported Trinidadian tobacco to Jamestown in 1610–11, English interest in Virginia tobacco perked up. By 1616, England was importing about 1,000 pounds of Virginia tobacco. By the mid-1620s, it had increased to about 10,000 pounds annually, and by 1630, Virginia was exporting 300,000 pounds of tobacco to England annually.[25] Interestingly, while James I had initially been outspoken in his loathing of tobacco, he ultimately mitigated his hatred of the stinky weed for personal economic gain. In 1618, the price of tobacco reached a high price of eight or nine shillings per pound in London.[26]

In 1619, the College of Physicians declared homegrown tobacco unhealthy, and James banned its production, purportedly to protect both the English smoker and the Virginian grower. However, James had a highly lucrative stake in the ban: in exchange for it, the Virginia Company allowed the Crown much higher duties on its tobacco imports.[27] This elucidates a very interesting trend in royal finance. As mentioned earlier with regards to the struggle between the Crown and Parliament over sources of royal finance, it would seem that tobacco duties and distribution rights would become a well-defined income stream for the English monarchy. By July 1624, a profit to the Crown of 93,350 pounds sterling was noted on 300,000 pounds of tobacco from Virginia, 100,000 pounds from the Somers Islands and 50,000 pounds from Spain.[28] This clearly set the hierarchy for importation proportion and priority concerning the point of origin.

For a variety of reasons, the Virginia Company failed in 1624, but the colony did not. Rather than seeing this toehold in America and the seemingly profitable tobacco trade languish, James opted instead to make the colony a royal settlement, thus entitling the Crown to all profits from this burgeoning trade. This also brought a measure of stability to Jamestown (in the form of governance, infrastructure and, eventually, the British army) and kept the slowly growing tobacco trade going. Tobacco was even used as currency within the colony, as the following table, dated December 1625, indicates:[29]

ITEM	PRICE IN POUNDS OF TOBACCO
Wine a gallon	3
Aquavitae a gallon	3
Cyder & Vinegar a gallon	2

London and Jamestown during the 1620s

ITEM	PRICE IN POUNDS OF TOBACCO
Sugar the lb.	1
Butter the firkin	20
Cheese 3 lbs.	1
"Neates lether 2 sold showes"	.2
"Neates lether 3 sold shows"	.3
Newfoundland fish the hundred	10
Canada dry fish the hundred	24
Canada wet fish the hundred	30

Note that sugar and tobacco were of equal value, which economically put both Jamestown tobacco and West Indian sugar on an equal footing—though perhaps not completely equal, as a pound of tobacco occupied more space in a ship's hold than did an equal weight of sugar, thus rendering a shipment of sugar more profitable (to shipowner and crew) than one of tobacco. As noted earlier, England and Parliament wrestled with the problem of how the king could "live of his own" and not off his subjects through excessive taxation. England and Parliament had witnessed the despotism of continental monarchs and were resolute in their conviction to avoid this in England. Monies earned through the distribution of commodities from the colonies was a way the Crown could infuse its coffers without taxing the people. Instead, the king would simply and shrewdly get the British people addicted to sugar and nicotine. The trick to keeping prices attractive in England was keeping overhead in the colonies low. Letters and appeals from Jamestown requesting logistical support steadily began to flow to England in the mid-1620s, as evidenced by the following petition, dated October 4, 1625, to the king by Sir George Yeardley, governor of the Jamestown colony:

> At his late coming from Virginia, his Majesty poor Colony was in great distress and ready utterly to perish for want of necessary supplies both of munition apparel and all other things, as also in regard of a late pretended Contract made by certain persons who drawing all the profit of his Majesty's poor subjects labours into their own purses, thereby utterly disheartened the whole Colony have required petitioner to beseech his Royal assistance for upholding said Colony. Finds since his arrival that order has been taken for the return of certain ships to Virginia with munition apparel and other necessaries for the relief of such as are remaining there until next year. Beseeches his Majesty to persevere in his gracious intentions for the supportation of that Colony and to command petitioner to attend the Privy

Council to declare the state of the Colony that such further order may be taken not only for the present but future preservation and subsistance of the same as shall be thought most meet.[30]

Implicit in the above stated appeal is a context of corrupt business dealings among "certain persons," who apparently overcharged the colonists for basic necessities and/or commodities. Additional appeals from Jamestown urged the king to enforce an importation monopoly on tobacco from Virginia and the "Summer Islands" and to not allow Spanish tobacco, or tobacco from the West Indies, to be imported into England, thereby undercutting the prices of Jamestown tobacco and returning the economy of the colony to one of abject poverty. In addition, keeping basic commodities at fixed prices (see table on pages 25-26) was another problem facing the planters at Jamestown. If the market were glutted by an influx of tobacco from other regions, Virginia tobacco would decrease in value and thereby force the planter to grow greater quantities of tobacco just to afford basic necessaries. The following letter, dated April 6, 1626, from the governor of Jamestown and the Virginia Company to the Privy Council outlines these concerns:

We must be inhabled by upholding the price of Tobacco, wee humbly beseech his Majestie to continue his favour in prohibiting the importation and saile of all Tobaccos, except from this Collony and the Summer Islands, and here we cannot but make remonstrance to your Lordshipps how providentiall these petty plantations of the English in the Salvage Islands in the West Indies must needs prove to this Collony in effect to the utter overthrowing of the benefitt of the sole importation grainted to us by his Majestie both in respect of the quantities they may send, and that under coller thereof much Spanish Tobacco may be imported and vented; and if the said prohibition bee not strictly and presily lookt to, the marchant (who hardly keepes himself, within the bounds of our proclamation concerning the rates of comodities) will take advantage there uppon to inhance his prices excessively, whereby the Collony will be kept in poverty as formerly.[31]

Therefore, the Crown was solicited to help stabilize the colony and the all-important tobacco trade—for which, in exchange for royal protection, price fixes and monopolies, the Crown would enjoy the lion's share of revenues generated by the sale of this smoky commodity back in mother England.

For the present, consumers and merchants in England tolerated this ridiculous distribution monopoly, made more ridiculous by the assertion that

all the tobacco imported into England was "for his Majestie's own immediate use."[32] In addition, a royal colony was entitled to benefits that a private joint-stock company did not enjoy, chief among them the (eventual) protection by the British army against the Powhatans, or native peoples of this region. The relationship between the colonists at Jamestown and the Powhatans was fraught with duplicity, antipathy and a fundamental unwillingness by the colonists to endorse any other cultural ethos than that of mother England. There were, of course, exceptions.

This contentious and difficult relationship culminated with the infamous Powhatan Massacre of 1622, during which the Powhatans, seeing their land and way of life evaporating with each arriving ship full of colonists, staged a massive uprising resulting in the deaths of more than 347 colonists.[33] Although the Virginia Company placed the blame for this incident on the

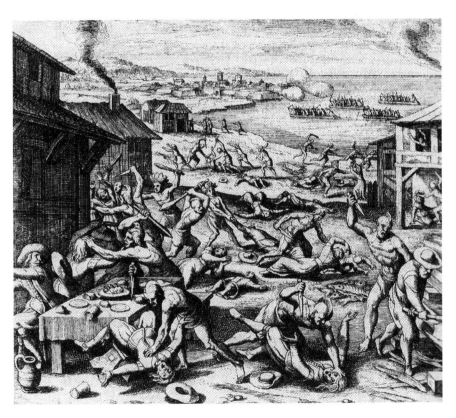

Powhatan Massacre of 1622. Woodcut by Matthaeus Merian, 1628. Seeing their land and way of life disappearing with each arriving ship, the Powhatans staged an uprising in 1622 that resulted in the deaths of 347 colonists.

colonists, the Crown—and consequently, England—eventually decided that the native populations of this region were not worth saving (through evangelism) and must therefore be dealt with using a martial methodology and ideology. In 1625, colonists pleaded with England to send no fewer than 500 fully equipped soldiers to Jamestown to ensure the safety of both the colonists and their tobacco plantations:

> *Those great and important works of suppressing the Indians… will require no lese nombers then five hundred soldiers, to bee yearly sent over with a-full years provision of victuall, apparell, armes, munition, tooles and all necessarys. to which worthy designes, the collony wil be alwaies ready to yeald their best furtherance and assistance as they have bine very forward since the massacre…*[34]

The Jamestown colony of 1625 was an interesting one, to be sure. While Fells and Sibsey plotted and planned their burgeoning tobacco empire in London, the colonists of this small fortress plantation town spent their days tending their tobacco crops (and anxious nights pondering what price their crops would fetch), hunting for food and worrying about Powhatan uprisings—after all, the aforementioned massacre had occurred only a few years ago.[35] The mortality rate in Jamestown tended to be much higher than in London, a fact that propagandists were not quick to admit or publicize. To remedy this, in 1621, the Virginia Company sent over in a one-year period fifteen hundred colonists in twenty-one ships.[36] In fact, all propaganda, cartography and policy of the day tended to be pro-colonization.

As mentioned earlier, England needed new commodities and new markets. The writings of John Smith in his 1624 *Generalle Historie* illustrate this point perfectly. This tract promised the potential colonist that "heaven and earth never agreed better to frame a place for mans habitations, were it fully manured and inhabited by industrius people."[37] Implicit in this statement was the abrogation of native people's claim to the land, which they had inhabited for seven thousand years. The notion of "industrious people" was defined as most definitely people who were not nomadic, who wore good English woolens and who worshipped the Protestant/Anglican faith—in short, those who were English.

James I died in 1625, and the throne of England passed to his son Charles, as mentioned earlier. By 1627, Charles I had finalized his position, as well as that of his predecessor, concerning tobacco. Note that the following two proclamations came only approximately six months apart:

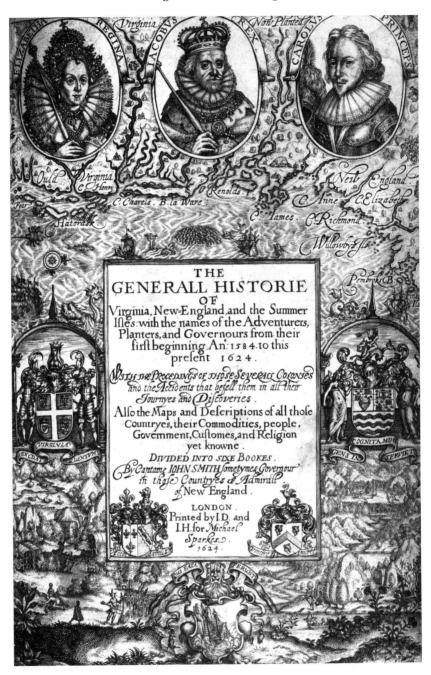

Captain John Smith's *Generalle Historie* of 1624. Note that the two most recent monarchs (Elizabeth and James) and the heir apparent to the throne of England (Charles) are at the top of this frontispiece. All were in support of the idea of English imperialism, and more pointedly, all were in support of infusing England's sagging economy with saleable commodities from colonial projects in America.

February 17, 1627: Confirming previous proclamations of 29 Sept. 1624, and 2 March 1625, prohibiting the importation and use of all tobacco not of the growth of Virginia and the Somers Islands, but because of the immoderate desire of taking tobacco which "prevailed throughout the kingdom, and the difference, or at least the opinion of difference" between Spanish or foreign tobacco and that of the plantations of Virginia, allowing the importation of 50,000 weight per annum of the former to the King's "own particular use."[38]

August 9, 1627: The growth of tobacco in England is strictly prohibited, as well as the importation of any Spanish or foreign without the King's special commission. No tobacco of the growth of Virginia, the Somers Islands, or any other English colony to be imported without license under the Great Seal, and when imported, to be sold to the King's Commissioners, for His Majesty's own immediate use, from whom only it may be bought.[39]

Even though the Crown had given the Jamestown planters what they had asked for, the colonists were a bit uneasy about the Crown establishing an effective monopoly on tobacco sales in England, especially with increased duties, as suggested by the deal James struck with the Virginia Company. Obviously, they did like the ban on importation of Spanish tobacco, as it raised the value of Virginia tobacco. Colonists had enjoyed trade with England as well as other countries—most notably the Netherlands. The earliest trade between the Netherlands and Virginia was about 1611, possibly earlier.[40] In fact, there was a Dutch faction in Virginia, just as there were representatives of Jamestown in the Netherlands. In 1618, Sir Thomas Dale (an Englishman) presented a petition to the States General of the Netherlands asking for seven years of back pay for being captain of a company "in your high mightinesses service."[41] Dale served as an administrator in Virginia and was on leave without pay from his service to the Netherlands, but he began drawing pay from the same as time went on, as he claimed he was "sailing to Virginia to establish a firm market there for the benefit and increase in trade."[42]

In 1619, the Dutch introduced the Jamestown settlement to slavery, which also established a lucrative and necessary relationship between the colony and Dutch traders. Tobacco cultivation was a labor-intensive pursuit, and many planters felt uncomfortable asking Englishmen to suffer the conditions necessary to yield the stinky weed profitably. Slavery was the solution to this dilemma. Fed up with restrictions from England in 1620, the Virginia Company prepared to send an entire tobacco crop to the Netherlands in

1621, claiming that its patent allowed this. It even dispatched an agent to Middelburg in the Netherlands to finalize this arrangement.[43]

As mentioned earlier, the English initially didn't like Virginia tobacco due to its "bite"; however, the Dutch did not have this problem, and they not only imported Virginia tobacco to the Netherlands but also acted as a distributor to the rest of Europe, the Ottoman Empire and North Africa.[44] Moreover, the Dutch offered colonists at Jamestown a greater variety of trade goods than England—often at better prices. A final incentive for trading with the Dutch can be seen in the customs duties levied on tobacco in both England and the Netherlands. London customs duties were considerably higher than those in Rotterdam; thus, colonists were quick and enthusiastic to trade with New Amsterdam (present-day New York City) to earn more on each pound of tobacco.[45]

By the 1640s, Amsterdam—the "Wall Street" of the seventeenth century and the center of trade with East India—was trading with Virginia. The success of the trade with the Dutch was based on their willingness to buy in bulk and to grant long-term credits.[46] The important and seemingly inevitable corollary to the trade with the Netherlands were the (English) Navigation

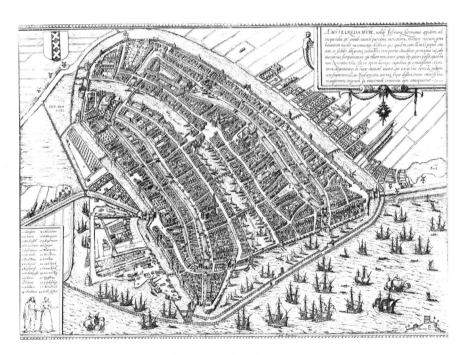

Amsterdam in 1574. Engraving by Braun and Hogenberg.

Acts of the 1650s, which specified that the colonies could only trade with England and that all goods had to be shipped in English "bottoms" (vessels). Is it any wonder that merchants were trying to get in on the tobacco trade by the mid-1620s?

It was within this vibrant and dynamic context that the voyage of the *Sparrow-Hawk* was conceived, planned and executed. The tobacco trade was seemingly a very good business in the 1620s. Jamestown was the place to be, and Fells and Sibsey wanted to get in on the action.

2

PLANNING A VOYAGE

In London, John Fells and John Sibsey gathered the necessary papers (their charter or land grant) and cash and likely traveled to the south coast of England during the late fall of 1626. Perhaps their captain, a Scot by the name of Johnston, joined them in London, or perhaps he was occupied in port. The ride to the south coast port towns would have been slow and bumpy—and chilly. What thoughts must have been going through their heads? Nobody can say for sure, but common sense would dictate that the bulk of their ruminations focused on details of their voyage. Perhaps they puffed away on clay pipes, dreaming of Virginia and the fortunes they were going to amass through the tobacco trade. Jeffrey Knapp argued that tobacco did not merely stand for the New World but also stood in for it, by transforming England into a New World all its own.[47]

Even though the crew of *Sparrow-Hawk* was described as a "rowdy bunch" by Governor William Bradford, we know that the men brought enough food to last about five or six weeks and that their ship just barely made it to America. It is unknown from which port they sailed, but the likely ports of departure for such a voyage would have been Dartmouth, Portsmouth, Plymouth or perhaps even one of the smaller port towns, such as Rye.

In 1626, John Fells and John Sibsey secured supplies and agricultural equipment (for tobacco monoculture), a crew of Irish farmers (most likely indentured servants) and Captain Johnston. They also needed a ship, so they found a smallish vessel of about forty-five feet on deck that had a "good run" and looked to be a "good sea boat."[48] Her name was unknown (we see

the name *Sparrow-Hawk* appear in the nineteenth-century writings of Amos Otis). The ship they chose may have been a rebuilt older vessel from the time when England fought the Spanish Armada.[49] The following table, although referring to naval vessels, indicates that ships were rebuilt frequently as a means to save money or perhaps correct aspects of their performance:

NAME	BUILT	REBUILT	INITIAL LIFESPAN
White Bear	1564	1589	25
Merbonour	1589	1613	24
Ark Royal	1589	1608	19
Due Repulse	1596	1610	14
Mary Rose	1555	1589	34
Hope	1558	1602	44
Bonaventure	1561	1587	26
Lion	1582	1609	27
Nonpareil	1585	1602	17
Defiance	1589	1613	24
Vanguard	1587	1619	32
Swiftsure	1574	1608	34
Crane	1589	1610	21
Quittance	1589	1605	16
Answer	1589	1604	15

The table above suggests that the average lifespan of a warship was about twenty-five years. The differences between warships and merchant vessels were manifested mainly by structural issues concerning armament, the most significant being the reinforcement of the gun deck necessary to take the added weight and strain of a large quantity of cannons. The difference between merchant ships and men-of-war during the early seventeenth century was by no means distinctive—that a ship of any kind must occasionally fight was, according to Violet Barbour, axiomatic.[50] England encouraged builders to construct stout ships that were armed and well manned to protect commerce. In addition, the government also wanted a supply of ships from which to supplement the navy should the need arise.[51] It is worth mentioning that both the *Mayflower* and the *Susan Constant* carried cannons for self-defense, and it is possible that the *Sparrow-Hawk* did as well (this will be discussed later in the book). In any event, the vessel that Fells, Sibsey and Johnston chose was small. Her exact configuration will be discussed in chapter four, but suffice it to say that she was most likely ship-rigged,[52] possessed enough space

to accommodate about twenty-five persons, had a cabin and had enough room in her hold to store provisions, trade goods, agricultural implements and ballast.

According to Governor Bradford, we know that the *Sparrow-Hawk* was a complete loss after she wrecked a second time on the Cape, which could suggest a number of things. Perhaps she was indeed an older ship that did not receive a rebuild, thus rendering her in a weakened condition. Or perhaps the storm that wrecked her a second time was especially violent— many ships have succumbed to the bars on and around Cape Cod. Perhaps it was a combination of the two. However, in a letter by schooner builders Dolliver and Sleeper to Charles W. Livermore in the 1860s regarding their findings concerning the *Sparrow-Hawk*, the suggestion was made that she may have been well built:

> *Notwithstanding the many years which this vessel has been exposed to the fury of the elements, and to the action of the shifting sands in which she has been buried, her outline has been remarkably well preserved. Only a practiced mechanical eye could detect a little inequality in her sides, in consequence of her having had a heel to port.*[53]

We do know that when she wrecked for the first time, a plank butt had become unfastened. Perhaps this occurred in multiple instances, thus rendering the vessel "wholly unfit for sea," as stated by Bradford in his account.

It is important to note that this was seafaring England at the turn of century. The defeat of the Spanish Armada in 1588 had clearly established England as the preeminent maritime power in the world. Such hubris and nationalism could have mitigated potential lingering doubts or fears that prospective "adventurers" may have had concerning their vessels, voyages or other logistical matters. It is true that some reports that came from the Atlantic world were suppressed or silenced by the Crown, merchants and propagandists in order to promote colonization.

One such example was the Hore expedition (a group of affluent English gentlemen) to the Labrador coast in 1536, the result of which was that Englishmen, the paradigm of all that was "civilized," resorted to cannibalism in order to survive. News of this would have compromised the bedrock ideology that England was trying to develop to justify taking American lands from the indigenous peoples. In other words, cannibalism was something that was (only) practiced by savages, not Englishmen. News of this type of event reaching the public would

have been disastrous and definitely would have undermined a budding ideology of imperialism and entitlement.

All available information in London, such as propaganda and Richard Hakluyt's *The Principal Navigations*,[54] as well as maps and charts by individuals like Captain John Smith and others, indicated that the *Sparrow-Hawk's* voyage would be a straightforward, if not simple, endeavor. They could not have been more wrong. However, even if Fells and Sibsey had lingering doubts about the success of their voyage and proposed enterprise, they most likely were tired of the taxes, perennial plagues, poor economy and severely limited opportunities for social mobility in England. Acquisition of new land was virtually unheard of unless you were a member of the gentry, royalty or had inherited it. America must have seemed, by comparison, like a land of limitless opportunity and definitely offered something new—the promise of a better life. To the right sort of person, the acknowledged dangers of the crossing must have seemed like a small price to pay for the potential reward of becoming a man who possessed land, status and relative freedom in the New World—the very nexus of what would come to be known as the American dream. In addition, colonial projects in the Americas and West Indies were a way in which England could get rid of some of the excess population that was beginning to strain the infrastructure and physical capacity of London. By the mid-seventeenth century, unemployment, which resulted from the decline of certain facets of the clothing trade, yielded a general feeling, as historian D.B. Quinn wrote, "that there was a surplus population which ought to be exported."[55]

Having chosen their ship, Fells and Sibsey would have next begun attending to issues of provisioning. Navigation of the Tudor and Stuart period was crude by today's standards, with much owing to the experience and judgment brought to the voyage by the captain. Charts of the Atlantic world were few and highly subjective in nature, as we shall see, so choosing a captain became a crucial decision. However, due to circumstances during the first quarter of the seventeenth century, the pickings may have been exceedingly slim. When Charles I ascended the throne, sailors felt the result of the monarch's contentious relationship with Parliament. Seamen were conscripted from the fishing fleets and merchant endeavors, such as trading or colonial voyages to America, to man the royal fleet. However, Parliament did not budget enough money to cover the cost of additional naval personnel.[56] This in turn contributed to a general feeling of malaise and dissatisfaction among sailors due to lack of proper clothing, food and pay. Another reason for the lack of experienced captains—at least in the Royal Navy during the 1620s—was the lack of foresight in not attracting and training a corps of lieutenants who

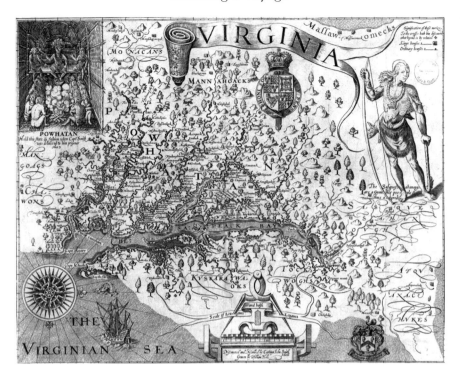

John Smith's Map of Virginia, discovered and as described by Captain John Smith, 1606. Engraved by William Hole. The map was created in 1606 but wasn't published until 1631. Note the sachem of the Powhatans in the upper left-hand corner and Smith's heraldic crest at the lower right-hand corner, which reads: "Vincere est vivere" (To conquer is to live).

could then rise to the rank of captains. Bradford's description of the voyage mentioned concern over the "sufficiencie of the master" and worried that he was "badly assisted." This could have been due to the fact that there simply were not enough experienced or good seamen available for the voyage.

Maps of the early seventeenth century were narrative in nature; in other words, they were more about a given mapmaker's social, political and economic agenda and cultural norms than impartial scientific fact. John Smith's maps of Virginia and New England are excellent examples of this phenomenon. For example, Lisa Blansett wrote that "the combined image and text of [Smith's] Map of Virginia reveal not only the intentions and agendas of both Smith and his culture, but also suggest the inconsistencies and multivalent significance of the Jamestown experiment."[57] Cartographic representations of a given region were important "tools of empire," wrote Nicolas Canny, and were also importantly skewed to favor colonization and to establish ownership of a certain region by a given country.[58]

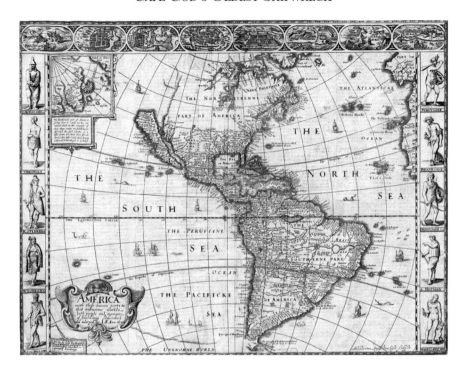

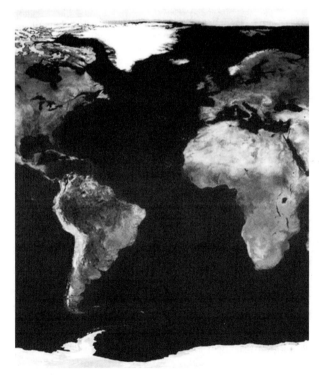

Above: FIGURE 1. *Map of the Americas and the North Sea and the South Sea*, circa 1626. Note that California is detached from the continent and the chronicling of indigenous peoples of the Caribbean in the left and right margins. *Courtesy of the National Archives, Kew Gardens, United Kingdom.*

Left: FIGURE 2. Satellite photo of the North Atlantic. Note the actual distances between continents, which are much greater than depicted in the 1626 map. In particular, note the distance between the southern coast of England and Cape Cod.

The Crown and England were desperately in need of finding new commodities and were willing to stretch the truth in order to motivate potential colonists to make the voyage to the New World. Often, distances were distorted to seem closer than they were in reality. Compare Figures 1 and 2. Figure 1 represents a map of the Atlantic world in 1626, and Figure 2 is a modern chart showing the same body of water. Note how much closer the North American continent appears in the early map. The influence of the Crown on such maps and narratives of the New World should not be underestimated.

Smith's maps also represent an image of negotiated acculturation—of the interface of the "civilized" and the other—one that favored the hegemonic agenda of mother England. Therefore, maps during the early modern period served a multiplicity of functions. They served to draft potential colonists by mitigating the vast distances between England and the Americas; they depicted the land being actively and seemingly already colonized, including indigenous people, who were serenely allowing this to occur in the context of the map. In addition, through the use of coded iconography, the maps rationalized and validated an ethos of imperialism through heraldic symbols of Crown and mapmaker, including phrases that rationalized imperialism, such as Smith's "Vincere est vivere" (To conquer is to live) on his 1631 *Map of Virginia*.[59]

In addition to propaganda, which manifested itself in the form of tracts like Smith's *Generalle Historie* and various maps that promoted and validated an ethos of imperialism, the literature of the day undoubtedly fueled and promoted colonization, adventures on the far shores of America and empire. Writing in 1906, one of England's first professors of English literature wrote that the works of Shakespeare and Marlowe were every bit as much circumnavigators of the world as Cavendish and Drake.[60] William Shakespeare, in his play *The Tempest*, was most explicit in his depiction of the Atlantic world and the dissonance created by the fierce and uncontrollable nature of the sea as contrasted with English cultural tendencies of order, hierarchy and social stratification. For example, in the passage "When the sea is: hence, what cares these roarers for the name of a king?"[61] Shakespeare is stating that a king may have sovereignty over land and subjects, but at sea, he was as powerless as any man. In fact, the much-maligned mariner had dominion on the rolling deep, as he could operate and navigate the ship.

Interesting, too, was the dichotomy that developed between official national rhetoric concerning dominion, empire and a carefully crafted ethos of a "Great Age of Elizabethan Seafaring" and the anxieties, worries and fears of those who actually experienced the Atlantic world. This anxiety

THE
TEMPEST.

Actus primus, Scena prima.

A tempestuous noise of Thunder and Lightning heard: Enter a Ship-master, and a Botefwaine.

Mafter.

Ote-fwaine.

Botef. Heere Mafter: What cheere?

Maft. Good: Speake to th'Mariners: fall too't, yarely, or we run our felues a ground, beftirre, beftirre.　　　　　　　　　*Exit.*

Enter Mariners.

Botef. Heigh my hearts, cheerely, cheerely my harts: yare, yare: Take in the toppe-fale: Tend to th'Mafters whiftle: Blow till thou burft thy winde, if roome enough.

Enter Alonfo, Sebaftian, Anthonio, Ferdinando, Gonzalo, and others.

Alon. Good Botefwaine haue care: where's the Mafter? Play the men.

Botef. I pray now keepe below.

Anth. Where is the Mafter, Boson?

Botef. Do you not heare him? you marre our labour, Keepe your Cabines: you do afsift the ftorme.

Gonz. Nay, good be patient.

Botef. When the Sea is: hence, what cares thefe roarers for the name of King? to Cabine; filence: trouble vs not.

Gov. Good, yet remember whom thou haft aboord.

Botef. None that I more loue then my felfe. You are a Counfellor, if you can command thefe Elements to filence, and worke the peace of the prefent, wee will not hand a rope more, vfe your authoritie: If you cannot, giue thankes you haue liu'd fo long, and make your felfe readie in your Cabine for the mifchance of the houre, if it fo hap. Cheerely good hearts: out of our way I fay.　　　　　　　　　*Exit.*

Gon. I haue great comfort from this fellow: methinks he hath no drowning marke vpon him, his complexion is perfect Gallowes: ftand faft good Fate to his hanging, make the rope of his deftiny our cable, for our owne doth little aduantage: If he be not borne to bee hang'd, our cafe is miferable.　　　　　　　　*Exit.*

Enter Botefwaine.

Botef. Downe with the top-Maft: yare, lower, lower, bring her to Try with Maine-courfe. A plague——
A cry within. *Enter Sebaftian, Anthonio & Gonzalo.*

vpon this howling: they are lowder then the weather, or our office: yet againe? What do you heere? Shal we giue ore and drowne, haue you a minde to finke?

Sebaf. A poxe o'your throat, you bawling, blafphemous incharitable Dog.

Botef. Worke you then.

Anth. Hang cur, hang, you whorefon infolent Noyfemaker, we are leffe afraid to be drownde, then thou art.

Gonz. I'le warrant him for drowning, though the Ship were no ftronger then a Nutt-fhell, and as leaky as an vnftanched wench.

Botef. Lay her a hold, a hold, fet her two courfes off to Sea againe, lay her off.

Enter Mariners wet.

Mari. All loft, to prayers, to prayers, all loft.

Botef. What muft our mouths be cold?

Gonz. The King, and Prince, at prayers, let's affift them, for our cafe is as theirs.

Sebaf. I'am out of patience.

An. We are meerly cheated of our liues by drunkards, This wide-chopt-rafcall, would thou mightft lye drowning the wafhing of ten Tides.

Gonz. Hee'l be hang'd yet, Though euery drop of water fweare againft it, And gape at widſt to glut him. *A confufed noyfe within.* Mercy on vs. We fplit, we fplit, Farewell my wife, and children, Farewell brother: we fplit, we fplit, we fplit.

Anth. Let's all finke with' King

Seb. Let's take leaue of him.　　　　　*Exit.*

Gonz. Now would I giue a thoufand furlongs of Sea, for an Acre of barren ground: Long heath, Browne firrs, any thing; the wills aboue be done, but I would faine dye a dry death.　　　　　　　　　*Exit.*

Scena Secunda.

Enter Profpero and Miranda.

Mira. If by your Art (my deereft father) you haue Put the wild waters in this Rore, alay them: The skye it feemes would powre down ftinking pitch, But that the Sea, mounting to th' welkins cheeke, Dafhes the fire out. Oh! I haue fuffered With thofe that I faw fuffer: A braue veffell

A　　　　　　　　　　　　　　　　(Who

Frontispiece of the opening scene of *The Tempest* by William Shakespeare. *From Rowe's 1709 edition.*

became manifest in the writings and works of literature of the time. Indeed, the voyage of the *Sparrow-Hawk* was admittedly a miserable and depressing one, but so was the voyage of the *Sea Venture*, the ill-fated third resupply mission to Jamestown in 1609 (to be discussed shortly), as chronicled by William Strachey. Many others alluded to anxieties and difficulties during their voyages, which we shall soon see. Some were never able to tell their tales; the sea simply swallowed them whole, leaving a brief swirl of foam against the pitiless gray-green of the turbulent North Atlantic.

There were two routes a potential Atlantic voyager could take: the southern route, which was longer and tended to be safer (especially during the winter), favored by the Spanish and, interestingly, the voyagers on the *Mayflower II* in the 1950s; and the northern route, which was faster but also more dangerous, especially in the dead of winter. Fells and Sibsey set out for Jamestown during the winter of 1626–27. The reason for choosing a winter departure date was to arrive in America in time for the spring planting season. Interestingly, six years earlier, the Separatists aboard the *Mayflower* had left in the fall to arrive in the New World before the winter set in, which to me seems like a far more prudent course of action.

Before leaving, the ship was provisioned for what was calculated to be a voyage shorter than six weeks, as we know from Bradford's account that they ran out of all their provisions by the six-week mark. One implication of this is that Fells and Sibsey did not plan adequately for the amount of provisions needed. However, the state of victualling was especially poor during this period. With cash being on short supply from the Crown and Parliament, victuallers often overcharged for poor-quality food and other provisions.[62] Nicolas Canny stated that it took six weeks to travel from the Chesapeake to London but that it took nine weeks to make the reverse journey.[63] Perhaps Fells and Sibsey made the mistake of assuming that it took the same amount of time to sail both to and from England on the northern route. On the return trip, currents would be in their favor; outbound from London, they would not. Even with accurate estimates of how long the trip would take, uncontrollable factors such as storms, becoming lost, damage to the ship and a weakened crew could all contribute to making a voyage longer than expected.

Captain John Smith's *Sea Grammar* of 1627 described some of the things that Smith recommended having aboard ship: "Fine Wheat flour close and well packed, rice, currants, sugar, prunes, cinnamon, pepper, green ginger, oil, Holland Cheese, wine vinegar, brandy, water, juice of lemons for scurvy, beef packed in vinegar, gammons of bacon, legs of mutton minced and

stewed, and oatmeal."[64] Interestingly, Smith provided a cautionary note, stating that a captain must provide enough men to handle the ship properly and not overburden a short-handed crew, as the men would become sick or injured. We know that many of the crew of the *Sparrow-Hawk* were in fact sick, and the master had scurvy. One explanation for this could be that there was not enough citric acid onboard to prevent scurvy. Another explanation could stem from the fact that, in Plymouth alone, there was rampant sickness during 1625, due to the return of the failed Cadiz expedition. A letter to the Privy Council mentions that "when the Cadiz expedition came back 1,600 of the townspeople died of diseases contracted from the soldiers and sailors."[65] The following passage sheds even more light on the horrible state of affairs with regards to this expedition:

> *The administrative incidents of this voyage enable us to measure the decadence of seamanship and the utter collapse of the official executive during the twenty years of peace. Efforts had been made to get the fleet away during the summer, but, owing to want of money, stores, and men, it did not sail till 8 Oct., too late in the season to do effective service. Disease raged amongst the soldiers and sailors assembled at Plymouth, and not a boat went ashore but some of its men deserted. Of 2,000 recruits sent first to Holland and then to Plymouth only 1,500 arrived at the seaport, of whom 500 were ill; 8 and the few professional sea captains there, who saw the unpromising material in men and supplies being collected, continually warned the council and Buckingham of the results to be expected from the quality of the men and provisions and the want of clothing.[66]*

We know that the ill-fated returning Cadiz expedition did not put in at Plymouth alone, but at many other ports on the south coast of England as well. Perhaps the crew and captain of the *Sparrow-Hawk* were sick before they even left port. Another explanation still could be that they became sick from spoiled provisions sold to them by an unscrupulous victualler in one of the port towns. It must, however, be stressed that the fate of a sailor in the merchant service was far preferable to that of his counterpart in the Royal Navy. Mark Oppenheim stated that were no recorded instances of mutiny on merchant ships unless they had been hired by the Crown.[67] In contrast to this assertion, we do know from Bradford's account that the crew of the *Sparrow-Hawk* was very close to mutiny.

Navigational equipment would have found a space aboard the *Sparrow-Hawk*, and this was a science still in its infancy. There was no GPS to liberate

man from the dictates of sun and stars. Instead, there were such items as a back staff, a cross staff, an astrolabe or astrolabe quadrant and, finally, a "nocturnal" (presumably for navigation at night). All of these instruments depended on the sun, moon or other celestial bodies. Some of these instruments were the basic forerunners to the modern sextant. It would take centuries and the life work of one John Harrison to prove that longitude could be established using a precision marine chronometer—but alas, that is another story.

Undoubtedly, our ship would also have had some sort of armament, as almost all merchant vessels carried at least a few cannons. This was due largely to the fact that piracy or privateering was omnipresent, but also because the Crown would often subsidize armament with the caveat that the ship could become part of the Royal Navy during wartime.

After bribing the necessary port officials—a common practice of the early seventeenth century—the captain, crew and passengers of what came to be known as the *Sparrow-Hawk* departed, as mentioned earlier, from a port most likely on the southern coast of England. Port books of the period are sketchy and unreliable at best, as many entries were falsified due to the customs corruption endemic at the time, especially the farther one was from London.

3

THE DESPERATE CROSSING, WINTER 1626–27

Departing with the outgoing tide, Fells, Sibsey and their "many Irish servants" aboard their tiny vessel would have sailed down the channel, past the needles and into the open Atlantic. It is important to remember that vessels of the early modern period did not behave like modern or even nineteenth-century sailing vessels. The only actual modern documentation in existence regarding the performance of a Tudor ship crossing the North Atlantic was the voyage of the *Mayflower II* in 1957. In an excerpt taken from the log of the *Mayflower II*, the following observations were recorded during the ship's voyage:

> There was a heavy quartering sea throughout the day and night with the ship pitching wildly. It was difficult to maintain balance…during the night sleep was impossible…Alan spoke to me about the matters which were causing him concern. He did not like the way the fore and aft masts worked and the bowsprit. The foremast was in his opinion, little better than a knotty broomstick, and the cordage rigging allowed too much play. The mainmast moved laterally about 10 inches or a foot at its head with each roll of the ship…the foremast stumbled and threw all of its rigging forward like a hard mouthed horse jerking at its rider. All these things may not have alarmed Captain Jones in 1620 but certainly alarmed our Captain![68]

It is also important to note that the *Mayflower II* was not built using Tudor planking and framing construction methodology; rather, it used double-

sawn framing with planks attached after the endoskeleton was erected. The original *Mayflower* almost certainly would have been built in the manner described by Mathew Baker in his *Fragments of Ancient English Shipwrightry* or similar to the methodology outlined in John Smith's *Sea Grammar*, which makes use of the floating frame style used to build *Sparrow-Hawk*. In essence, the *Mayflower II* was built using better and certainly sturdier methods of construction than that used on the original. Still, she had an interesting crossing.

Villiers took the southerly route (five thousand miles), which meant sailing down to the Canary Islands before making a westerly course for the West Indies and then finally heading north to Massachusetts, as Villiers claimed that the replica was "not galeworthy" due to an insufficient shakedown period before making the Atlantic crossing.[69] In contrast, the northerly or intermediate route was approximately three thousand miles and was used by the original *Mayflower* and presumably the *Sparrow-Hawk*. It is also important to note that contemporary naval architects and shipwrights can only approximate the hull designs and shipbuilding methodology of the seventeenth century, as there is only limited existing documentation on this subject (this topic will be explored in greater detail later in the book).

Our tiny forty-five- or fifty-foot ship would have entered into the vast expanse of the North Atlantic in the dead of winter, where seas reached epic heights of sixty feet and gales and fierce storms occurred frequently. The daily life aboard the *Sparrow-Hawk* was by no means comfortable. There would have only been a fire pit or crude hearth, constructed of brick on a platform below and aft of the foremast and windlass, for warmth and cooking. Some of the smoke vented through a grating set into a hatch on deck, while the rest simply stayed below, yielding a smoky, dark and dank environment. The ship pitched and rolled endlessly. Food was most likely a combination of salted or pickled meat; ship's biscuit or "hard tack"; brackish water; wine, beer or other spirits; and probably very few fresh vegetables or fruits. Those fruits and vegetables they did bring aboard would have been consumed early in the voyage to prevent spoilage. We know from Bradford's account that the crew was sick with scurvy. Of course, the incubation for this foul disease could have begun whilst the crew was still on terra firma, as the Tudor diet tended not to be heavy on either green vegetables or citric acid. (It is comforting to see that some things haven't changed on the Sceptered Isle!) Straw mats would have composed a bed, probably rife with bugs or moldy from the marine environment. The crew slept in a foul-smelling dark and smoky environment, most likely shared with a few pigs, chickens, sheep

and maybe a goat as well. We know from the Otis account that numerous beef and mutton bones were found in the artifact when the ship emerged in 1863. The following excerpt from Bradford's account describes the most desperate part of the *Sparrow-Hawk*'s crossing:

> *They had lost themselves at sea, either by ye insufficiencie of ye maister, or his ilnes; for he was sick & lame of ye scurvie, so that he could but lye in ye cabin dore, & give direction; and it should seeme was badly assisted either wth mate or mariners; or else ye fear and unrulines of ye passengers were such, as they made them stear a course betweene ye southwest & ye norwest, that they might fall with some land, what soever it was they cared not. For they had been 6. weeks at sea, and had no water, nor beere, nor any woode left, but had burnt upall their emptie caske; only one of ye company had a hogshead of wine or 2. which was allso allmost spente, so as they feared they should be starved at sea, or consumed with diseases, which made them rune this desperate course.*[70]

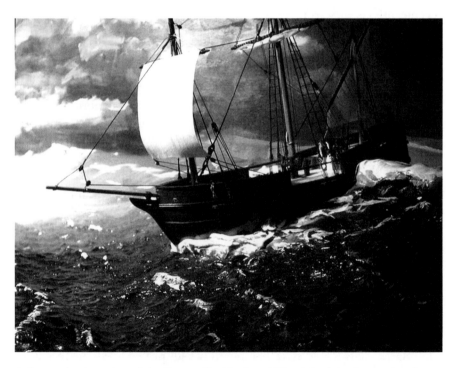

A diorama by the author of the *Sparrow-Hawk* in the middle of the Atlantic, running along under fore course, furled main course and lateen on the mizzen. *Photo courtesy of the author.*

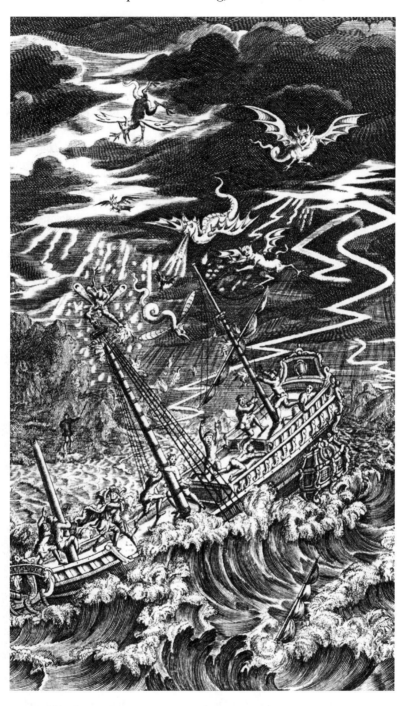

Title page of William Shakespeare's *The Tempest*, taken from the 1623 First Folio. Some aspects of *The Tempest* are thought, by many scholars, to be informed by William Strachey's tract on the voyage of the *Sea Venture*.

It is interesting to read tracts written in the early modern period, as their anxiety is described in such detached verbiage as "concerned for the sufficiency of the ship." In reality, these people must have experienced a particularly virulent species of terror that we can only imagine. Perhaps at this juncture, in retrospect, the filthy, disease-ridden and overcrowded London streets didn't seem quite so bad.

It is highly likely that part of one's day aboard the *Sparrow-Hawk* would have been spent manning the pump, as vessels in the early modern period leaked, or "worked," excessively due to the system of framing and planking used. Fortunately for the crew, the rig on such a vessel would have been mercifully simple: a small foresail on the foremast, a course and topsail on the main and a lateen sail on the mizzen. During fierce winter storms, perhaps only a lateen on the mizzen, a furled main course and topsail and the sail on the foremast (foresail) would have been used. We know that Alan Villiers lowered and shipped the lateen on the *Mayflower II* to improve the ship's performance and stability.[71]

One thing that would not have been expected, imagined or welcomed, however, were the epic winter waters of the raging North Atlantic. The following is an excerpt regarding a fierce storm encountered by the crew of the *Sea Venture*:

> *We could not apprehend in our imaginations any possibility of greater violence; yet did we still find it not only more terrible but more constant, fury added to fury, and one storm urging second more outrageous than the former, whether it so wrought upon our fears or indeed met with new forces…made us look one upon the other with troubled hearts and panting bosoms, our clamors drowned in the winds and winds in thunder. Prayers might well be in the heart and lips but drowned in the outcries of the officers: nothing heard that could give comfort, nothing seen that might encourage hope…It is impossible for me…to express the outcries and miseries, not languishing but wasting his spirits, and art constant to his own principles but not prevailing.[72]*

Strachey's tract conveys his utter amazement at the intensity of the storm and man's inability to do anything to control it, which resulted in despair and feelings of hopelessness. The following passage from the same tract indicates the sheer magnitude of the surf:

> *Once so huge a sea brake upon the poop and quarter upon us as it covered our ship from stern to stem like a garment or a vast cloud larger; it filled her*

brim full for a while within, from the hatches up to the spardeck. The source of confluence of water was so violent as it rushed and carried the helm-man from the helm and wrested the whipstaff out of his hand.[73]

It is important to remember that *Sea Venture* was larger than the *Mayflower*, and both were larger than the *Sparrow-Hawk*. The "whipstaff" mentioned in this passage is used to steer the ship; it is a lever connected to the tiller, which in turn is fastened to the rudder.

After about five weeks, morale was exceedingly low aboard the *Sparrow-Hawk*. After six weeks at sea, the little group of weary adventurers was on the verge of mutiny. According to Bradford's journal, Captain Johnston was so sick that he could only feebly utter instructions from the floor of his cabin near the door to the sailing master. His instructions were quite simple: make for land.

When the breaking surf was finally heard on what is today north Chatham/south Orleans, the crew managed to drop anchor just off the coast. They did

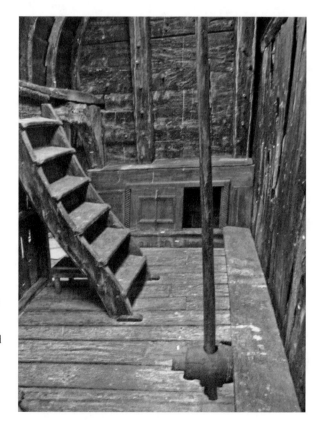

The whipstaff of the *Vasa*, 1628. The whipstaff was connected to the tiller, which in turn was fastened securely to the rudder. The vessel was steered by moving the staff either to port or starboard. *Photo courtesy of Peter Isotalo.*

49

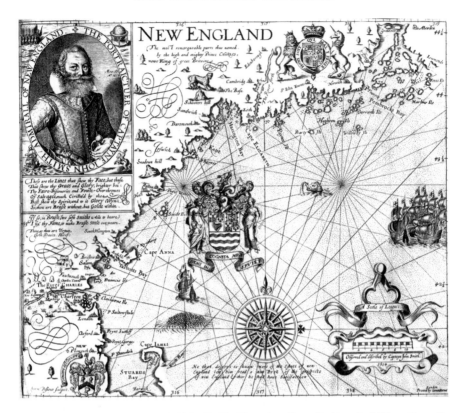

Map of New England by Captain John Smith. Note that Cape Cod is called "Cape James" in honor of King James I. Cape Cod Bay is called "Stuards Bay"; Barnstable is "Barwick"; and Provincetown Harbor is "Milford Haven."

this to avoid being smashed to bits on the bars and breaking surf of the outer shore of Orleans and Chatham. As their anchor cable strained and groaned, they noticed a small cut in the outer shore, through which they thought they could see calmer water. It is interesting to note that this break in the outer shore beach has recently reopened, suggesting a cyclical nature to the otherwise unpredictable and ever-shifting sands of Cape Cod (or Cape James, as Captain John Smith called it). Perhaps the French moniker of *Cape Malbarre* ("Bad Bar") was and is most fitting for the treacherous and shifting bars of the Cape, home to over three thousand shipwrecks (and those are only the recorded ones).

After a final tortuous groan, the anchor cable parted with a loud crack. The *Sparrow-Hawk* was now being ineluctably pushed toward the lethal surf and bars of the outer shore. Pooling their collective courage and energy, the weary crewmen of the *Sparrow-Hawk* asked for providential deliverance and steered for the cut.

4

CAPE JAMES, CAPE MALBARRE, CAPE COD!

The little ship approached the cut as the surf crashed and roared all around her. It was night, and visibility was poor. The winds were blowing at gale force. Whatever sail she was carrying would have undoubtedly been minimal. Finally, approaching the mouth of the cut, the little Tudor ship ran aground on a bar near the opening to "a small blind harbor," as Bradford called it. A surging wave pounded the battered little ship and, lifting and pushing her, helped her to pass through the opening (cut) into Manomoyake Bay.[74] During the course of this grounding and subsequent storm surge, the butt end of a plank sprang from its frame, causing the vessel to fill almost half full of seawater.

This must have been the icing on the cake for the weary and dispirited crew of the *Sparrow-Hawk*. With the break of day, the waterlogged, weak and weary captain and crew thanked Providence for their deliverance. They were doubly thankful that they had not been thrown overboard by would-be mutineers. They could at last allow the anxiety of the voyage to ebb from their minds and succumb to the flood of fatigue (and sickness) that would surely follow such an ordeal.

They had landed on the northeastern part of Chatham, and soon the waterlogged Englishmen saw what Bradford noted in his journal as a group of native peoples, presumably from the Nauset tribe, paddling toward them. As befitted the orthodox European mentality, the Englishmen expected to be attacked and began priming their matchlock muskets. But they were pleasantly surprised when they discovered that these people spoke English.

A recent photo of the cut that has reappeared at almost exactly the same spot where the *Sparrow-Hawk* passed through in 1626. In the foreground is a beach where the ship may have wrecked the first time. *Photo courtesy of the author.*

Asking if "they were the Governor of Plymouth's men, or friends," the natives offered to the weary and anxious band to "bring them to ye English houses, or carry their letters." This indicates a certain measure of acculturation and at least trade between the colony at Plymouth and the native peoples of the outer shores of Cape Cod. Bradford noted that "Squanto" spoke English well, suggesting that native people had encountered English-speaking people prior to 1620, most likely from the New England fisheries, or perhaps they had picked up a few words or phrases from Gosnold and his men when they visited north Chatham in 1602. This is interesting, as nineteenth-century historiography tends to depict native Cape people as being somewhat isolationist during the seventeenth century. In any event, Bradford was summoned, and he came down from Plymouth in a shallop, bringing spikes, oakum and corn for the crew of the *Sparrow-Hawk*, who were on the verge of starvation.

After the crewmen of the *Sparrow-Hawk* repaired their ship by refastening and caulking the sprung plank end, they wrecked her a second time. This is especially interesting, as the waters of what is now Pleasant Bay are protected

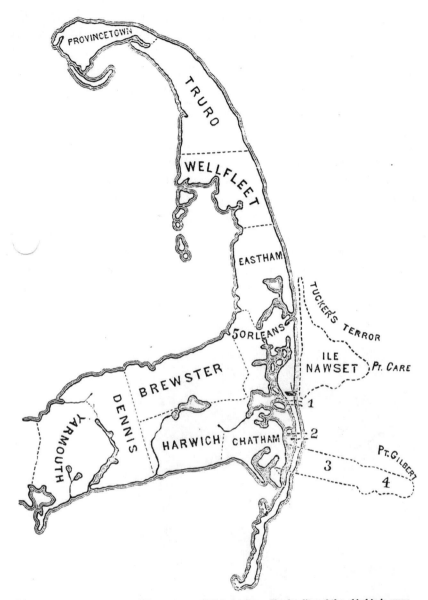

1. Site of former entrance to Potammagutt or old ship harbor. The locality of the old ship is represented in black.
2. Present entrance to Chatham harbor.
3. Island ledge.
4. Webb's island.
5. Namskachet creek.

Map of Cape Cod showing the location of the *Sparrow-Hawk*'s second wreck site. Note "the cut," indicated by the numeral one, which has recently reappeared. This is the slot through which the *Sparrow-Hawk* passed before presumably wrecking on the northeastern shore of Chatham. *Drawing from a booklet by Amos Otis.*

by the outer shore, rendering them much calmer than the Atlantic. Perhaps the *Sparrow-Hawk* was in the process of passing back through the cut and was driven back by breaking surf and high winds. The location of her final resting place is documented on the map by Amos Otis. The fact that she was beyond repair suggests that the vessel was indeed in a fragile state—or perhaps the crewmen had simply had enough and lost their nerve. At this juncture, Bradford invited these miserable and weary travelers to stay with him at Plymouth. There is some credible evidence to suggest that Bradford may have been in the vicinity during this time, conducting land surveys.[75] It would also appear as though the group had some coveted trade goods—diverse kinds of clothing, hosiery and shoes—which they traded for corn. Perhaps these articles of clothing were samples of England's (depressed) woolen trade, or perhaps they were exotic or fashionable clothes obtained in Amsterdam or elsewhere.

After winter ended, Fells and Sibsey were given a piece of land to work, and John Fells and his servants raised a good amount of corn, indicating and underscoring that at least some of the *Sparrow-Hawk*'s men were competent at husbandry, or farming. In spite of their agrarian prowess, this group did

Frans Hal's *The Laughing Cavalier*, 1624. Although Dutch, this is an excellent example of the attire worn in the first quarter of the seventeenth century. Note the expression of self-confident smugness on the cavalier. *Wallace Collection, London.*

not fit in well with the pious Pilgrims. Or perhaps the pious Pilgrims did not fit in with the English population of the rest of Massachusetts. In any event, it is worth reviewing the actual text of Bradford's account (for full account, see appendix A):

And so their request was that they might have leave to repaire to them, and soujourne with them, till they could have means to convey them selves to Virginia; and that they might have means to trasport their goods, and they would pay for ye same, or any thing els wher with ye plantation should releeve them. Considering their distres, their requests were granted, and all helpfullnes done unto them; their goods transported, and them selves & goods sheltered in their houses as well as they could.

The cheefe amongst these people was one Mr. Fells and Mr. Sibsie, which had many servants belonging unto them, many of them being irish. Some other ther were yt had a servante or two a peece; but ye most were servants, and such as were ingaged to the former persons, who allso had ye most goods. After they were hither come, and some thing setled, the maisters desired some ground to imploye ther servants upon; seeing it was like to be ye latter end of ye year before they could have passage for virginia, and they had now ye winter before them; they might clear some ground, and plant a crope (seeing they had tools, & necessaries for ye same) to help to bear their charge, and keep their servants in imployment; and if they had oppertunitie to departe before the same was ripe, they would sell it on ye ground. So they had ground appointed them in convenient places, and Fells & some other of them raised a great deall of corne, which they sould at their departure. Ths Fells, amongst his other servants, had a maid servante which kept his house & did his household affairs, and by the intimation of some that belonged unto him, he was suspected to keep her, as his concubine; and both of them were examined ther upon, but nothing could be proved, and they stood upon their justification; so with admonition they were dismiste. But afterward it appeard she was with child, so he gott a small boat, & ran away with her, for fear of punishmente. First he went to Cap-Anne, and after into ye bay of ye Massachussets, but could get no passage, and had like to have been cast away; and was forst to come againe and submite him selfe; but they pact him away & those that belonged unto him by the first oppertunitie, and dismiste all the rest as soone as could, being many untoward people amongst them; although ther were allso some that caried them selves very orderly all ye time they stayed. And the plantation had some benefite by them, in selling them corne & other provisions of food for cloathing; for they had of diverse

kinds, as cloath, perpetuanes, & other stuffs, besids hose, & shoes, and
such like comodities as ye planters stood in need of. So they both did good,
and received good one from another; and a cuple of barks caried them away
at ye later end of somer. And sundrie of them have acknowledged their
thankfullnes since from Virginia.[76]

John Fells apparently tried to make something else grow when he impregnated a maidservant, denied it and then, when she began to show, ran off with her in a small boat. By this point, Bradford and his fellow Separatists had had enough of the cast of characters from the *Sparrow-Hawk*. In the final analysis, they just didn't fit in with the folks at Plymouth. Samuel Eliot Morison snidely wrote in 1954 regarding the Pilgrims:

I sympathize with the Englishman who said he wished that instead of
the Pilgrims landing on Plymouth Rock, Plymouth Rock had landed on
the Pilgrims. Or with the Honorable Joseph Choate who, after hearing
a long and lugubrious account of the sufferings of the Pilgrim Fathers
at a New England Society dinner, offered a toast to the Pilgrim Mothers
because, he said, they had to endure all those hardships, and endure the
Pilgrim Fathers too![77]

It appears that the other colonists who were then in Massachusetts practiced a more moderate or even liberal form of Puritanism than the radicalized dogma of the Separatists. Bradford described the occupants of the *Sparrow-Hawk* as a "rowdy bunch" or "untoward" (although he offered that there were also some well-behaved folks in the group), but perhaps the Pilgrims were simply an "uptight bunch." In any event, in the summer of 1627, after John Fells got his girlfriend pregnant and Bradford asked the whole group to leave, the *Sparrow-Hawk*'s passengers and crew were given passage in a pair of barks to conclude their voyage to Jamestown.

5

JOHN SIBSEY'S VIRGINIA

Bradford's account of the *Sparrow-Hawk* incident concludes with the following passage: "So they both did good, and received good one from another; and a cuple of barks caried them away at ye later end of somer. And sundrie of them have acknowledged their thankfullnes since from Virginia."[78]

There are a few interesting points regarding this passage. The first is that it required two barks to contain the passengers and crew of the *Sparrow-Hawk*, lending credence to the view that she was indeed a vessel larger than the average bark (i.e. *Sparrow-Hawk* was a ship). The second is that the passengers and crew did, in fact, arrive in Virginia, which was their target destination in the first place. Finally, as evidenced by the letters of thanks they sent to Governor Bradford from Virginia, they were not as rude as Bradford initially described. In fact, judging from evidence found in Virginia, Captain John Sibsey attained his American dream and exhibited traits that were decidedly not rowdy.

When Sibsey and the crew of the *Sparrow-Hawk* finally reached Jamestown during the late summer of 1627, the object of their quest was seemingly about to slip into decline. The tobacco trade had seen a boon in the mid-1620s, but by 1628, prices were starting to fall. In addition, the very character of this region was in a process of transformation, one that was very different from the initial struggle of the first quarter of the seventeenth century. Instead of ships carrying too many nobles or gentlemen who could not really do anything useful, ships were now arriving in Virginia carrying people who would build a diverse economy and infrastructure for the colony. Among

those arriving at Jamestown at this time were carpenters, sawyers, bricklayers and makers, bakers, butchers, chandlers, grocers, weavers, skinners, tanners and, of course, farmers (husbandmen).[79]

As mentioned earlier, this was also a time during the evolution of the colony that the Crown was endeavoring to secure a tobacco monopoly from the planters in Virginia. Into this dynamic atmosphere our weary group from England, by way of Plymouth, was tossed. Interestingly, in the minutes of the Council of Virginia dated October 12, 1626, an entry states:

> *Now wheras ye said man is not deliverd accordingly, ye George Menesy marchant doe retain & keepe fowre hundred pounds waight of tobacco of ye goods of ye said John Hart, ye if the said man now alledged to bee sent & shipped on a ship fro Ireland Mr. Fells master, does not arrive and bee delivered to ye said John Bainham by the 25th day of December next.*[80]

The association of "Ireland" and "Mr. Fells master" seems too coincidental to not be our John Fells of the *Sparrow-Hawk* with its "many Irish servants." It seems he was actively trading across the Atlantic between Virginia, England and Ireland.

As for Captain John Sibsey, we know that he purchased tracts of land on August 17, 1637, as follows: "1500 acres on the westernmost branch of Elizabeth River and on the north side, and 1500 acres next adjoyn.g upon the land of Francis Towers, north upon the Maine River, east as farr as the Westermost Pting of an island called Crany Point."[81] More than ten years later, on March 26, 1649, Sibsey purchased more land as follows: "50 acres called by the name of Craney Island, lyeng and being at the mouth of Elizabeth river, and 80 acres called the Thickett. Beg.g on the South side with the land of Mr. Sewell, decd."[82] It seems Sibsey did in fact purchase a good deal of land—in aggregate, a total of 3,130 acres. If he planted tobacco on even half of that land, he would have been a moderately successful man by any standards.

We also know that, unlike Bradford's assessment of this group, John Sibsey, at least, was concerned with matters decidedly nonsecular. Apparently, he allowed religious services to be held in his home, as evidenced by the following statement, dated July 19, 1637, in reference to a court order mandating that a certain Thomas Clark should ask forgiveness from one Anne Clark for her "defamation": "Heere now in Court, and on the next ensuing Saboth at Capt. John Sibsey's in the time of divine service."[83] People's homes were used to conduct religious services due to the lack of any dedicated church

structure. The court ordered the construction of a church building in 1637, but the structure was still incomplete a year later.[84] However, this did not stop services from being conducted. The first record of this appears in May 1638 in reference to yet another sordid encounter:

> *Whereas it doth appeare that Richard Loe of Eliz river plantr hath most falsely…scandalized Anne Ruskinge…It is therefore ordered that the said Richard Loe shall…aske forgiveness the next Saboth at the parish Church of the Lower Norf and the next ensuing Saboth at the river and furder that the sd Richard Loe shall pay for the building of a pair of stocks.*[85]

By November 1638, parishioners were fed up with their unfinished church. A court order at that time conscripted Sibsey and Henry Seawell (Sewell) to oversee completion of the structure:

> *Whereas their hath beene an order of Court granted by the Governor and Counsell for the Building and erecting of a church in the upper pct.* [precinct] *of this County with a reference to the Commander and Commissioner of the sd County for the apointing of a place fitting for the building thereof the said order being in part not accomplished, But standing now in election to be voyde and the worke to fall into ruine, Wee now the sd Commissioners…doe appoint Capt John Sibsey and Henery Seawell to procure workemen for the finishing of the same and what they shall agree for with the sd workemen to be levied by the apointment of us the Commissioners.*[86]

The same determination that aided Sibsey in getting his "rowdy bunch" across the Atlantic in 1626 was now being summoned to help finish a church in his neighborhood. The location of the first church in lower Norfolk was Seawell Point, as described in an agreement to pay the parish's second (paid) minister.[87] The church at Seawell Point became the Elizabeth River Parish Church. No documentation survives that describes the size and type of this church; however, it is assumed to have been built of brick, owing to difficulties in completing it and in obtaining enough brick due to the death of a local brick maker.[88] Interestingly, Seawell's Point was located on a parcel of 650 acres owned by Captain William Tucker that abutted Captain John Sibsey's land.[89]

Sibsey did not restrict his endeavors to matters of local piety; he also was interested in local politics. He became a burgess in 1632, along with Captain Thomas Willoughby and his neighbor, Henry Seawell. They were chosen

to represent "from Water's Creek to Marie's Mount."[90] In 1632, he was also elected to the council. He appeared again as a burgess in 1641, along with John Hill and John Sidney, all representing lower Norfolk County. In reference to his service as a member of the council, it is noted that Captain John Sibsey died in 1652 in Virginia.

This leader of the "rowdy bunch" of untoward people who crossed the Atlantic on the *Sparrow-Hawk* led a full, productive and useful life after reaching Virginia. He became a person of substance in the community, holding church services in his house and then helping to complete the first church in the Norfolk region. He was a successful planter, as evidenced by his landholdings, and politician, as his years of service in the House of Burgesses and on the council indicate.

But what became of Fells and the others? Most likely, they also acquired tracts of land and tried to fit into the regional economy and society as best they could. Alternatively, perhaps they stayed for a time and then returned to England, disenchanted with colonial Virginia. The reality of the colony and its surroundings must have been very different from the initial romanticized/idealized vision they had based on the propaganda back in London.

6

REEMERGENCE—THE "OLD SHIP" RECONSIDERED

The timbers of the "old shippe" appeared briefly in 1782, after which the shifting sands of the Cape's outer shores covered her again. Her secrets would have to wait another several decades before revealing themselves. After a fierce gale swept over Cape Cod in 1863, when the winds died down and the sun broke through the clouds, those first pale rays illuminated what must have looked like the bones of a dinosaur—or at the very least, an anachronism that was at odds with the usually featureless outer shore. At long last, the weary and enigmatic bones of what would henceforth be known as the *Sparrow-Hawk* finally appeared from beneath the shifting sands of Cape Cod.

The derivation of this name is an interesting one. A family by the name of Sparrow settled near Old Ship Harbor in 1675. According to James Sparrow in 1863, the old vessel had always been buried in the sands of "Potununuquut Harbor...and its name was 'Sparrow-hawk'"[91] It seems to me very coincidental that this man's name and the vessel's were one and the same. The provenance for the "Hawk" portion of the name is unknown. Bradford referred to the vessel simply as "a ship." There is no mention of any name for this vessel in the seventeenth-century tracts regarding the wreck. It is a pity that the site on which she rested did not have the benefit of modern methods of archaeological study, recording and analysis—we could have known so much more! But alas, the context being what it was, she was at least extricated from the sludgy sands, and we do have at least one very good account of the wreck's reemergence, as chronicled by Amos Otis.

The Otis tract yields some very interesting clues to the overall configuration of the vessel. Otis also made a drawing of the remains of the wreck, which, if accurate, provides some rather compelling clues. The first thing that should be noted from the Otis drawing is the position of the main mast step (mortise) on the keelson—it is approximately amidships (see below). This would lend credence to the assertion by Bradford (and myself) that the vessel was indeed ship-rigged (three masts) and not a bark or ketch or some other rig, as H.H. Holly and others speculated. Moreover, another notation that Otis made was that there was a substantive quantity of timber up forward by the stem: "The ship builder can judge of the peculiarity of her form by the amount of dead wood at her stem, and the molding of her frames."[92] This could lend credibility to a drawing made by William A. Baker (designer of the *Mayflower II*) of a proposed colonial bark, circa 1640, that shows the foremast as stepped on the stem. Baker's arrangement would support and validate the extra robust scantlings found on the *Sparrow-Hawk*; they would have been needed to support a foremast stepped on the stem. Tudor and Stuart engravings and paintings show the foremast on

5. Amos Otis's drawing of the remains of *Sparrow-Hawk*. Reproduced from his *Loss of the Sparrow-Hawk in 1626*, Alfred Mudge & Son, 1865.

Drawing of the remains of the *Sparrow-Hawk* by Amos Otis. Note the position of the mast step mortise, which is almost exactly amidships. This supports the conclusion that she may well have had a foremast.

The replica ship *Godspeed*, built for the Jamestown-Yorktown Foundation, has her mast stepped far forward, probably terminating on the stem. The *Godspeed* replica is slightly larger than the *Sparrow-Hawk*, but not by much.

ships of this period as being very far forward indeed. In addition, replica ships built for the Jamestown-Yorktown Foundation, such as the *Godspeed*, also have their masts stepped far forward. Of those expressing opinions on the subject, there is universal agreement that the vessel had a mizzenmast. Therefore, it is at least plausible that the *Sparrow-Hawk* may have been ship-rigged. Otis also had other interesting observations such as mentioning that the shape of the vessel was peculiar, and in particular, he emphasized the long, tail-like fin of the vessel's deadwood and sternpost area. He also mentions that people came from as far away as three miles to see the wreck. Granted, this was before the American entertainment industry became preponderant, so perhaps, comparatively speaking, this was pretty exciting. However, if media coverage and visitation numbers concerning even part of a shipwreck are any measure, shipwrecks remain a source of excitement and interest on Cape Cod to the present day. Otis also noted that many people took souvenirs from the wreck. One can only imagine what was taken or what we could have learned if these treasure hunters had left the

artifact intact. Interestingly, I have received many communications over the last few years from people all over the Cape who claim to have a piece of the *Sparrow-Hawk*, thus underscoring its allure and people's desire to own a piece of history.

The construction methodology of the *Sparrow-Hawk* is enigmatic, as her framing and planking tend to suggest Tudor shipbuilding of the early to mid-sixteenth century, yet the wreck occurred in 1626. However, as mentioned earlier, ships were often rebuilt to extend their serviceable lifespan, so conceivably she could have originally been built around the time of the Armada and then rebuilt after the turn of the century. Wooden boats of the period could last a long time, but a vessel built in the first half of the sixteenth century remaining seaworthy a century later would be asking a lot of a piece of wood. However, the *Sparrow-Hawk*'s English oak futtocks and floors feel as solid today as they must have when she was built so many years ago. Vessel design during the sixteenth century was a work in progress, as builders wrestled with issues of stability and sailing performance and as new innovations and improvements from the Atlantic world were adopted at various shipyards in England and elsewhere. We know the English Tudor warship *Mary Rose* was rebuilt at least once.[93]

For comparative analysis in trying to see where the construction methodology of the *Sparrow-Hawk* fits, we must look at several examples and records spanning the sixteenth and seventeenth centuries. In chronological order: the wreck of the *Mary Rose* (1565), Mathew Baker's *Fragments of Ancient Shipwrightry* (1580s), *A Manuscript on Shipbuilding* (circa 1600, as copied by Sir Isaac Newton), Captain John Smith's *Sea Grammar* (1627) and, finally, the wreck of the Swedish *Vasa* (1628). Other influences that would have had an impact on vessel construction during this period would undoubtedly include John Hawkins's notes concerning his rebuilding of the English fleet in the 1570s (much of which was co-opted by Mathew Baker in his *Fragments*) and the report by the Canadian government on the Basque whaling vessel (circa 1560s) found in Red Bay.

As a very general overview, England began its shipbuilding (naval) tradition in earnest when Henry VIII imported Italian shipwrights to build his navy in the early sixteenth century. At this point in time, it is important to remember that the galley was the preeminent maritime fighting machine, and its building techniques were imported into England in the minds of the Genoese shipwrights. This ideology focused on basically a shell of planking that was built first or concurrently with the frames that supported it. There was a gradual

shift over the next two centuries to first building a rigid skeleton, to which planks were then attached—in short, a reversal of the original (Mediterranean) technique of shipbuilding. The construction analysis of the *Mary Rose* indicates that there were partial attempts at moving away from the floating frame construction methodology that characterized Mediterranean gallery construction.[94] Interestingly and importantly, Smith's tract on shipbuilding, written in 1627, supports the "scarphed frame" construction methodology that we also see somewhat in the *Mary Rose*. However, the problem remains: the *Sparrow-Hawk* was built using the floating frame technique, which defies easy categorization or placement in a linear progression of shipbuilding methodological evolution. Even in her day, she was enigmatic.

Perhaps the answer lies in the theory that for large naval vessels, built up—or scarphed—framing was necessary to achieve the size of the desired vessel. The *Mary Rose* and the *Vasa* were both large state warships; perhaps for smaller vessels or various independent shipbuilders, the tradition introduced by the Italian shipwrights in the early sixteenth century survived well into the seventeenth century. Another fascinating clue found on the *Sparrow-Hawk* that acknowledges the inherent problems of the floating frame were the "gluts," as documented by Hobart Holly and W.A. Baker in the 1960s. Gluts were little wooden wedges that were driven between the frames and floor to presumably prevent them from excessively "working," or twisting in a seaway, as mentioned earlier. They may also have been used to help frame the vessel, as this would eliminate the floating of frames between the floors, rendering floors and first futtocks contiguous to one another.

It is very important to note how discordant and problematic the results were of combining building techniques that worked well for the scope and fetch of the Mediterranean into vessels that would be transiting the colossal seas of the North Atlantic. Undoubtedly, these vessels were exposed to stresses never imagined in the comparatively "calmer waters" of the Mediterranean, English Channel and other coastal waters. There are several tracts that illustrate this point, one of which described the cracking of the main deck beam aboard the original *Mayflower*. Compressive stresses on the outer hull could have caused this to occur, as could rotten timber.[95] You will recall that mariners used a printing press to jack the beam back into position. Another example is the ill-fated *Speedwell*, which was forced to either turn back to England or founder. What is interesting about this particular incident is that it demonstrates what could occur to a vessel of this period and building methodology when subjected to stresses encountered in a seaway, as opposed to in calmer waters dockside:

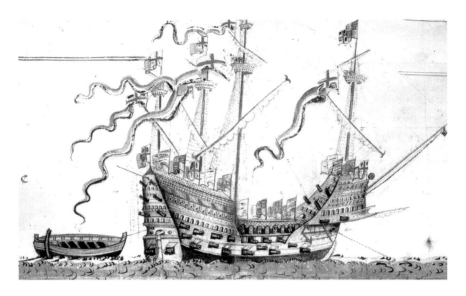

The *Mary Rose*, circa 1546. *From the Anthony Roll of Henry VIII's navy.*

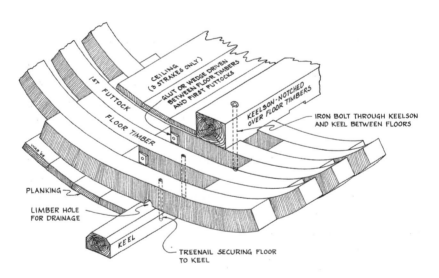

Drawing showing the floating frame type of construction methodology. Note the "gluts" or wedges that were driven between floors (attached to the keel) and the futtocks (which "floated" between the floors). The fact that the frames were not joined to the floors caused the whole structure to "work" in a seaway. *Drawing by W.A. Baker. Courtesy of the Pilgrim Hall Museum.*

Being thus put to sea they had not gone farr, but Mr. Reinolds the masterr of the leser ship complained that he found his ship so leak as he durst not put further to sea till she was mended. So the master of the biger ship (caled Mr. Jonas) being consulted with, they both resolved to put into Dartmouth and have her ther searched and mended, which accordingly was done...She was hear thorowly searcht from steme to sterne, some leaks were found and mended, and now it was conceived by the workmen and all, that she was sufhciente, and they might proceede without either fear or danger...they put to sea againe, conceiving they should goe comfortably on, not looking for any more lets of this kind; but it fell out otherwise, for after they were gone to sea againe above 100 leagues without the Lands End, houlding company togeather all this while, the master of the small ship [Speedwell] complained his ship was so leake as he must beare up or sinke at sea, for they could scarce free her with much pumping. So they came to consultation againe, and resolved both ships to bear up backe againe and put into Plimmoth, which accordingly was done. <u>But no spetiall leake could be founde</u>, but it was judged to be the generall weaknes of the shipe, and that shee would not prove sufficiente for the voiage.[96]

According to this passage, the great leaking occurred while the *Speedwell* was at sea and presumably was a result of the planking and framing excessively working or twisting in a seaway. This was made especially clear, as indicated by the underlined portion above, when they returned to port and could not find a leak. Strachey's tract also includes a very similar description of a serious leak aboard the *Sea Venture* that the crew was unable to locate:

So as joining in the public safety there might be seen master, master's mate, boatswain, quartermaster, coopers, carpenters, and who not, with candles in their hands, creeping along the ribs viewing the sides, searching every corner, and listening in every place if they could hear the water run. Many a weeping leak was this way found and hastily stopped...But all was to no purpose; the leak (if it were but one)...could not be found...the waters still increasing and the pumps going, which at length choked with bringing up whole and continual biscuit...it was conceived as most likely that the leak might be sprung in the bread room; whereupon the carpenter went down and ripped up all the room but could not find it so.[97]

Here again, the constantly working and twisting of framing and planking would have rendered a fixed-location leak elusive, as stresses on a given

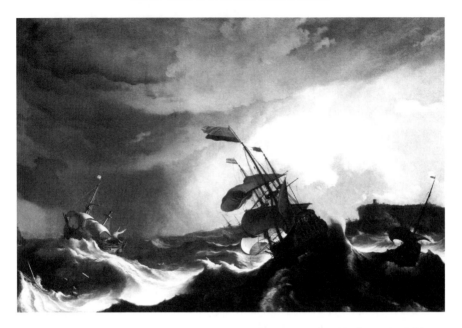

Storm at Sea by Willem van de Velde the Younger (1633–1707), painted before 1707. This painting illustrates the pitching and rolling encountered by vessels on the North Atlantic. Note the men attempting to regain control of the fore course (on both vessels), from which the sheets have obviously parted.

section of the ship would have varied as the ship pitched and rolled in a seaway. To illustrate this point even more graphically, Strachey's tract mentions that the ship's seams (in every joint) had "spewed out her oakum [caulking material]," indicating that the seams between the planking were working tremendously:

> *It pleased God to bring a greater affliction yet upon us; for in the beginning of the storm we had received likewise a mighty leak. And the ship, in every joint almost having spewed out her oakum before we were aware… was grown five foot suddenly deep with water above her ballast…This, imparting no less terror than danger, ran through the whole ship with much fright and amazement, startled and turned the blood and took down the braves [courage] of the most hardy mariner of them all.*[98]

Contained in this tract, we see the omnipresent danger and horror that accompanied this voyage and undoubtedly countless others. According to the tract, the ship leaked enough water to fill the hold five feet "above her ballast," causing mass panic aboard and instilling fear that "turned the

blood" and drained the courage from "the most hardy mariner of them all." Another tract that illustrates the frailty of vessels of this period is described in a lawsuit prosecuted in 1646 concerning a voyage made by the ship *Fox* of Aucusion, Holland. The vessel was described as of roughly 260 tons burthen, which would yield a vessel of just under one hundred feet. The lawsuit apparently occurred due to the fact that this ship was wholly unfit for such a voyage. The following is an excerpt from the suit:

> *At sea, the seaven & twentieth of November 1646.*
> *A testificacon of all the seamen belonging to the Shipp called the* Fox... *concerning the insufficieincy of the said ship...having found amiss in her... her luffe knee being broken; secondly her plankcks working afore and alsoe in the hould; thirdly her plancks and knees betweixt decks workeing and bolts broken and Trunnells: fourthly in her sternne wee found a great Leake: fifthly, all her Seames afore and after above water...very leakey...sixthly her sides workeing both from the deck; Seaventhly her main mast was crack...thre is serverall beames broken, and seaverall kness come from the side.*[99]

This voyage took place during the mid-seventeenth century and indicates most graphically what the forces of the North Atlantic could do to a ship of this period. Many vessels were simply swallowed by the sea. Perhaps a clerk back in England, while nibbling on his midday meal, anxiously pondered the port book entry indicating that the ship had indeed left port, but no word concerning her arrival or return had been received since. What happened to those doomed souls, no one will ever know for sure, except that they perished somewhere in the vast expanse of the heaving and pitiless foam-flecked Atlantic. Perhaps sea birds briefly circled their watery grave before swiftly continuing their purposeful journey in search of their next meal.

Another explanation for ships of this period not being able to stand up to the forces of the North Atlantic would be the generally poor state of shipbuilding prevalent during the reigns of James I and Charles I, especially with regards to the navy. Queen Elizabeth I, in conjunction with others,[100] was responsible for creating a Royal Navy that was the envy of the civilized world, but the same cannot be said for those who followed in her wake. The following is a commentary on the state of the Royal Navy under Charles I:

> *The ships were leaky and their gear defective; the* St. George *was fitted with sails which were used by the* Triumph *in 1588, while her shrouds were "the old* Garland's *and all stark rotten." Another officer writes:*

"There was great wrong done…by pretending the ships were fit to go to sea." Even before they left port the casks were so faulty that beer came up in the ships' pumps, so that by November they were reduced to beverage of cider "that stinks worse than carrion, and have no other drink."[101]

I do not wish the reader to think that Tudor shipbuilding was inadequate or executed in poor fashion. I merely am trying to emphasize that shipbuilding during the sixteenth and seventeenth centuries was in a state of evolution. The Atlantic experience undoubtedly provided the context in which many improvements to, and innovations in, global shipbuilding occurred. As mentioned earlier, John Hawkins's rebuilding of the English fleet in the decade leading up to the clash with the Spanish Armada was one such example. It is also worth mentioning that when Amos Otis described the remains of the *Sparrow-Hawk* in the early 1860s, he commented on how well constructed and fitted her timbers were—237 years after she wrecked and after being submerged in the sand for this period.

Finally, it is important to view shipbuilding during the sixteenth and seventeenth centuries not as something that occurred in a vacuum in a particular region or country, but rather as an organic and ongoing process that was subject to various influences—among them Dutch, Spanish, Basques, French and English, even stretching back to ancient Greece and Rome. It is entirely specious to think that any one type of (national) shipbuilding evolved independent of outside influence. It is also important to note that in spite of the formulaic nature of many of the tables and axioms offered by Baker, Smith and others, vessel construction undoubtedly varied from yard to yard, each builder adopting and adapting methodologies and techniques that suited his particular sensibility or style. Thus, the old bones of the *Sparrow-Hawk*, though only partially complete, are more easily understood or interpreted once we understand the context(s) in which she was built.

THE *SPARROW-HAWK* ON THE BOSTON COMMON, PROVIDENCE AND BACK TO PLYMOUTH

After America was ravaged by an awful civil war resulting from polarized Southern and Northern ideologies, Americans struggled to define who they were as a people during the early years of Reconstruction and in the decades to follow. In 1865, Charles Linnell and Leandor Crosby paid to have the *Sparrow-Hawk* brought to Boston from Cape Cod to be exhibited (page 72). It is especially poignant that the *Sparrow-Hawk* was displayed on the Boston Common in the city that provided the context for the Revolution and our country's break from British hegemony and rule. Nearly one hundred years later, at the close of the bloodiest and most traumatic war ever fought on American soil, stood a relic that harkened back to the founding of this nation by those few hardy adventurers who arrived over two hundred years ago. Perhaps the *Sparrow-Hawk* served to reinforce and undergird a nation that needed a reminder of why it was founded.

In spite of the seeds of civil war, the *Sparrow-Hawk* could be viewed as a humble arbiter to bridge these two poles. She was sailed to America to provide her occupants with the riches afforded by the tobacco trade. Some of this came to pass eventually, but her legacy was that she was an example of the hybridization of what would come to be known as distinctly Northern and Southern. But most importantly, she served, then and now, a symbolic role, serving as a reminder that the North and South were not as polarized and different as this last awful war had made them out to be. Her bared and still graceful bones erected on the Boston Common harkened back to the early days of America, when there seemed to be, at least from the shores of England, a land of limitless opportunity just across the pond.

This anachronistic artifact undoubtedly provided a welcome distraction and respite from the chaotic and confusing aftermath of the Civil War, as every American struggled for a common identity through which the nation could heal and become whole again. Assuming a revisionist or even romantic perspective, we could argue that the *Sparrow-Hawk* symbolized a people and a culture that defy easy categorization or bifurcation. America was, in the end, not a simple division of two disparate halves—the corrupt and slave-ridden South versus the pious and economically diverse North. Here was a voyage that contained people who possessed a desire for both religiosity and economic gain, for both social status and the ability to, through their own efforts, contribute and influence their community. How many great Americans were self-made men, and how dearly does this quality resonate with the American public even today? In this light, the *Sparrow-Hawk* serves as a symbol of the hybridization of qualities common to both North and South.

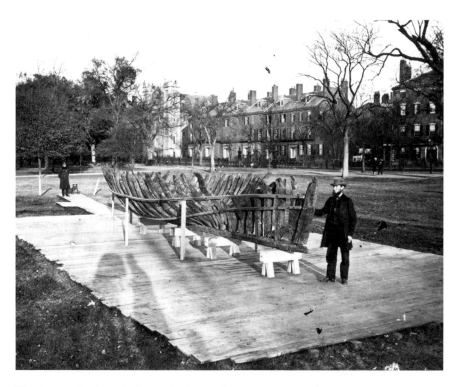

The *Sparrow-Hawk* on display on the Boston Common. Leander Crosby is standing by the sternpost. Note the policeman near the bow and the photographer's shadow in the foreground. *Courtesy of the Pilgrim Hall Museum.*

The *Sparrow-Hawk* on the Boston Common, Providence and Back to Plymouth

It is interesting that just five years after the *Sparrow-Hawk* appeared on the Boston Common, museum building in America began in earnest, as if to both create and affirm our collective history, to imbue it with permanence and relevance and to galvanize in the collective American psyche the idea that we as a people, in spite of the epic carnage of our Civil War, stood united in our conviction to press on and become something that could not be torn asunder ever again. At the close of the Civil War, America needed to be reminded of its past—that it had one that was rich and far-reaching. America was hungry for a unifying over-arching identity that had nothing to do with the Mason Dixon line. From the 1870s onward, America sought to collect and preserve its national treasures, and new museums were built in every major American city—granite temples to our cultural identity.

While on display on the Common, the *Sparrow-Hawk* was viewed as a great curiosity, the appeal for which was near and dear to the hearts of all Americans. The American public had always had a hunger for the new, the bizarre and the oddities or freaks of nature. Linnell and Crosby hoped to capitalize on this appetite by bringing the *Sparrow-Hawk* to Boston. However, their gamble did not pay off as they hoped, and the "great curiosity" was sold to Mr. Charles W. Livermore of Providence, Rhode Island. It was disassembled and placed in storage in Providence sometime in 1865–66. In the December 1882 issue of the *Proceedings of the Massachusetts Historical Society*, there is reference to a letter written by Charles Livermore to a Dr. Deane that stated:

> *You will no doubt remember "Ye Ancient Wrecke" which was exhibited on Boston Common in the fall of 1865. I was at that time a member of the Boston Common Council, and obtained permission of the Mayor to place it there, so that it might be easily examined by the antiquaries of the State. Yourself and many others took much interest in it at that time: and I believe it was through your influence I was presented with a copy of Bradford's "History of Plymouth Plantation" by the Massachusetts Historical Society, which contains, on page 217, an account of the wreck. I still own the old wreck, and being much broken in health am desirous of finding the most suitable permanent resting-place for it while I am able to attend to it. The wreck is no doubt the oldest example of ancient ship-building to be seen in this country, and on account of its connection with the early history of the Colony it ought to be preserved. I write you at this time to ask you kindly to give me your views as to the most suitable place for it, as I have very little acquaintance with the societies of Massachusetts. I*

enclose a pamphlet published at the time; also a small photographic picture of the ship. I have one or two quite large pictures, but they cannot very well be sent. The small one will recall the wreck to your mind.[102]

Dr. Deane wrote back to Livermore and said he would bring up the matter at the next meeting of the Massachusetts Historical Society; he also opined that he felt the artifact belonged in Plymouth and that the Pilgrim Society should be charged with its care for future generations. Livermore responded with the following:

The wreck is all there, just as you saw it in Boston, and can easily be taken out, dusted, and set up in any locality selected for it. An ordinary freight-car would be required for its transportation…I have often thought of Plymouth as a final anchorage for the old ship; but as I have never been there myself, and have no acquaintances there, I have been able to learn but little about the place or the Plymouth Society. I am quite willing the wreck shall go there if you think it the best place for it, and shall be pleased to present it to the Society if they will provide a suitable room for it where it can be seen to good advantage by visitors. I ought to say that I am not able to bear the expense attending the removal of the wreck to Plymouth, nor will my health permit me to take the care of its removal. Under these circumstances it seems necessary that the Society should send some suitable person to attend to the matter. I have paid all the original expenses of the rescue of the old ship from the sea, as well as all the cost of its care and protection since that time, which amount to a considerable sum for me. Now, if some individuals or Society are willing to take hold where I find I must leave off, this very interesting relic of "ye olden time" may be visited by many generations yet to come. I still have the pipes and other things found in the old wreck, including the wooden pump-box, in very good condition considering its great age. I have always kept it under a glass bell…I shall be very grateful to you if you will aid me in arranging this matter. Your knowledge of such things enables you to select with good judgment, and your acquaintance will make it easy for you to do what I cannot accomplish myself. I feel interested to have the old ship permanently located while I am here to do what I can towards it. I shall be pleased to have you mention the matter to your Society [the Massachusetts Historical Society] *if you think proper.*[103]

Deane continued by informing members of the society that Livermore had preserved some clay pipes found in the wreck and that he had seen

Photographed by Montague Cooper Kindness
 Ian Forbes-Robertson, Esq.

MESSAGE SENT BY TAUNTON, MASSACHU-
SETTS, TO TAUNTON, ENGLAND, IN 1889,

The frame made from the timbers of the *Sparrow-Hawk* to commemorate Taunton, Massachusetts's 250th anniversary. This item was sent to Taunton, England.

on the occasion of the two hundred and fiftieth anniversary of our city. The frame is cut from a timber that came from the English vessel "Sparrowhawk," which was wrecked off Cape Cod in 1626. The hull of this ship is now in Pilgrim Hall, Plymouth, Massachusetts.

some similar to these in England dating to the beginning of the reign of Charles I.

By an informal vote, a motion was made by the Massachusetts Historical Society to give the artifact to the Pilgrim Society of Plymouth, Massachusetts (which owns and operates the Pilgrim Hall Museum).[104] Incidentally, shortly after the *Sparrow-Hawk*'s enshrinement at Pilgrim Hall, a frame was fashioned from some of her timbers to create a memorial plaque from the town of Taunton, Massachusetts, to Taunton, England, commemorating the former's 250th anniversary. Clearly, this represented a time in our history when artifacts were not protected from such uses. I wonder how many other interesting and important pieces of historically significant material culture were "modified" in this way.

Other pieces of the wreck have found new homes as well. The *Sparrow-Hawk* carried many ballast stones, one of which is in the permanent collection of the Pilgrim Hall Museum; others have served as doorstops, paperweights and various other utilitarian non-antiquarian uses in homes all across the Cape. The quantity and variety of people on Cape Cod who claim to have a piece of the wreck is astounding. I was approached several years ago by some folks in Orleans who claimed to have some of the *Sparrow-Hawk*'s planking. The timber looked similar to those in the possession of Pilgrim Hall, and there were definitely holes for trunnels; however, there have been a lot of shipwrecks on the Cape over the years. Dendrochronology or Carbon-14 testing might be a way to establish the veracity of some of the claims put forth by various individuals on the Cape. Furthermore, it is interesting to note the number of streets in Orleans and Chatham that bear the name "Old Harbor." One such street is a stone's throw from where I work (Atwood House Museum/Chatham Historical Society) and makes its way toward the very place where the *Sparrow-Hawk* wrecked.

The *Sparrow-Hawk* artifact was acquired by the Pilgrim Hall Museum located in Plymouth, Massachusetts, in 1889. It has been there ever since and remains an interesting, if anomalous, piece of the Pilgrims' story. Stephen O'Neill, curator of Pilgrim Hall Museum, had the following to say about the artifact:

> *"There was a ship," wrote Plymouth's Governor William Bradford, "with many passengers in her and sundrie goods bound for Virginia." With these simple yet tantalizing lines, Bradford began the story of the ship known today as the* Sparrow-Hawk. *The vessel's remains were left behind in the mud and marsh of Pleasant Bay on Cape Cod in 1626, uncovered by a storm and exhibited on Boston Common in the 1860s, and deposited in Pilgrim Hall Museum in 1889. Although such a storied history would seem to make the* Sparrow-Hawk *an icon of the earliest English settlers in both New England and Virginia, the ship has often suffered from its own mysteries. Its name is uncertain and based on 19th century local lore. Its construction is unusual enough for each new generation of maritime scholars to present a new interpretation. Despite its relative anonymity, the ship's importance cannot be underestimated. The* Sparrow-Hawk *is a unique and invaluable artifact from the early 17th century, and its preservation contributes to the modern understanding of the Atlantic crossing that brought the early Virginians and New Englanders to their colonies.*

The *Sparrow-Hawk* on the Boston Common, Providence and Back to Plymouth

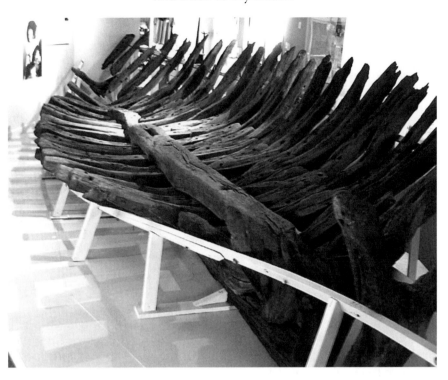

The *Sparrow-Hawk* reinstalled at the Cape Cod Maritime Museum in Hyannis. *Photo courtesy of the author.*

In 2005, while serving as director and curator of the Cape Cod Maritime Museum in Hyannis, I negotiated the loan of the *Sparrow-Hawk* from the Pilgrim Hall Museum for an exhibit I was planning on Cape Cod in the seventeenth century. Stephen O'Neill and I painstakingly disassembled the artifact, packed it up and moved it to Hyannis. The *Sparrow-Hawk* returned to Cape Cod after 146 years! Stephen and I then repeated the slow and careful process of reassembling the artifact in its cradle. The cradle was and is the most important part of this process, as it preserved the shape of the vessel—something that the floors and futtocks were unable to do because they "floated," as mentioned earlier. After the artifact had been reinstalled in the exhibit space, I began to theorize what the *Sparrow-Hawk* may have looked like in her entirety back in 1626. This led to extensive research on the vessel using period texts, manuscripts and the fine work that many others had done to derive replica vessels representative of the early modern period.

8

RECONSTRUCTING THE
SPARROW-HAWK

THE HULL

In the interest of insatiable curiosity and at the risk of sheer speculation, how might a vessel such as the *Sparrow-Hawk* actually have been constructed? What might she have looked like in her entirety? To reconstruct her, it will be necessary to rebuild her using the archaeological remains and specific tracts dealing with the subject of ship construction in the early part of the seventeenth century. As mentioned earlier, some of these tracts include Thomas Hariot's (incomplete) notes on shipbuilding (circa 1608), Captain John Smith's *Sea Grammar* (1627), the 1600 manuscript copied by Newton, portions of Mathew Baker's *Fragments of Ancient Shipwrightry* (1586) and, finally, Strachey's description of two pinnaces—the *Deliverance* and the *Patience*—which provides some compelling additional clues.

Before beginning construction, we must sketch out the basic proportions of our proposed vessel. As a general rule, Mathew Baker suggested that the breadth should be between one-half and one-third the length of the keel and the depth between one-half and one-third of the breadth.[105] This provides us with a range to work with but few specifics. Mathew Baker ascribed the following proportions (length to breadth to depth) in 1586 for a ninety-six-ton ship: 1 to .416 to .208.[106] These are reasonable guidelines with which to generate some basic proportions of the *Sparrow-Hawk*. The length of the extant portion of the *Sparrow-Hawk*'s keel is approximately twenty-eight feet, ten inches; it may have indeed been longer to accommodate the scarf, but not

much judging by the way the frames and floors are oriented to one another. Therefore, I will round it up to thirty feet to include scarf for the stem.

Multiplying .416 x 30 feet=12.48 feet as a proposed beam, and .208 x 30 feet=6.25 feet as a proposed depth of hold. Plugging these numbers into the length x width x breadth equation and dividing by 100, we arrive at about 23½ tons burden, which is woefully shy of the 40 tons estimated by Otis and H.H. Holly. Alternatively, we could use the formula that W.A. Baker used for the *Mayflower II*, which was based on the *Crane*, a ship built by Richard Chapman in 1590. This ship's proportions were as follows: length-breadth ratio of 2.31 with a depth equal to half the breadth.[107] So, using the *Sparrow-Hawk*'s 30-foot keel as a control, we can generate a beam of 13 feet and a depth of hold of 6 feet, 6 inches, which would, using the tonnage formula, yield 25.35 tons burden. Finally, there are dimensions in William Strachey's 1606 account for the pinnaces *Deliverance* and *Patience*. The *Patience* had the following dimensions: keel, 29 feet; beam, 15 feet, 6 inches; depth of hold, 8 feet.[108] Using the same tonnage formula, this would yield a vessel of about 36 tons burden—which is close to the 40-ton estimate mentioned earlier—and this set of dimensions includes an 8-foot depth of hold, which is closer to the Dolliver and Sleeper and Holly's description of *Sparrow-Hawk*'s proportions. In the case of the 29-foot keel, it's right on the money. I would therefore like to generate two iterations of the hull—one using the *Crane*'s proportions (6½-foot depth of hold) and one using the *Patience*'s proportions (8-foot depth of hold)—and let the reader decide which is most accurate.

Next, it will be necessary to generate the midship section for both models. To do this, I will employ a process used by W.A. Baker in generating the *Mayflower II*'s midship section. Baker calculated that the flat portion of the floor was about one-fifth of the half breadth[109] for reconstructing the *Mayflower II*'s master frame. The remaining floor timbers of *Sparrow-Hawk* support this ratio. Therefore, using his methodology for reconstructing the *Mayflower II*'s midship section, we can reconstruct the *Sparrow-Hawk*'s midship section. The midship section is like taking the center slice out of a loaf of sliced bread and laying it on the kitchen counter—the outline of that slice of bread is what we are talking about.

The Strachey tracts states that the *Deliverance*, the larger of the two pinnaces built, had a floor that was roughly one-third of the total maximum beam. However since the *Sparrow-Hawk* was ostensibly a ship and not a pinnace, and since the archaeological remains also support a shorter floor length, I'll use the one-fifth floor proportion that W.A. Baker advocated for both midship sections.

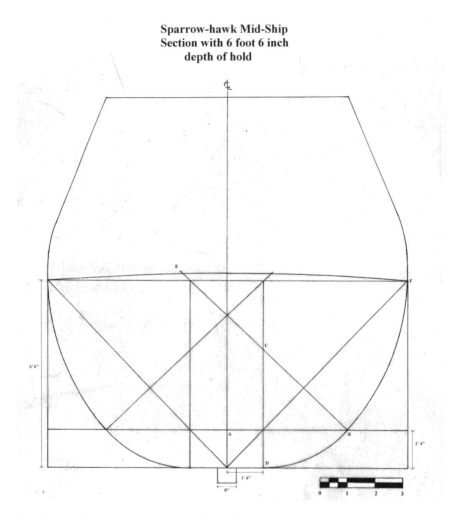

**Sparrow-hawk Mid-Ship
Section with 6 foot 6 inch
depth of hold**

The *Sparrow-Hawk*'s midship section or frame. *Drawing by author.*

The portion of the *Sparrow-Hawk*'s midship floor timber that is the flattest is about twelve to seventeen inches (before it begins to compass, or form the "rungheads," as mentioned in Smith's *Sea Grammar*). Add to this half of the width of her keel—another four inches—and we arrive at (conservatively) sixteen to twenty-one inches. Thus, using the formula of Mathew Baker as interpreted by W.A. Baker to derive his midship section for the *Mayflower II*, we can derive the same for the first iteration of the *Sparrow-Hawk*. For the second version, the process is repeated, but the depth of hold is increased to eight feet (figure y).

Given a keel length of about thirty feet, we next need to establish the overhangs, or "rakes," at bow and stern. Dolliver and Sleeper mentioned that the *Sparrow-Hawk* had "a great rake of stem," which is consistent with the following passage in *Sea Grammar*:

> *The rake forward is near half the length of the keel, and for the rake afterward about the forepart of the rake forward, but the fore rake is that which gives the ship good way, and makes her keep a good wind, but if she not have a full bow, it will make her pitch her head much into the sea; if but a small rake forward, the sea will meet her so fast upon the lowes she will make small way.*[110]

Implicit in Smith's statement is the idea that the rake of the stem needed to be both full enough to prevent plunging and fine enough by the gripe to allow the vessel to make "good way" or hold her course. According to Smith, the *Sparrow-Hawk*'s rake forward would be almost 15 feet, which would seem to be in agreement with Dolliver and Sleeper's comment. W.A. Baker noted that the sum of the overhangs was equal to the maximum beam, with the forward stem rake being larger than the stern—which might be a more moderate approach. Therefore, the *Sparrow-Hawk*'s length between perpendiculars could be approximately 43 feet (30-foot keel + 13-foot beam),

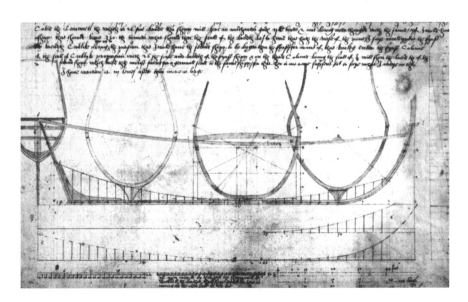

Mathew Baker's *Fragments of Ancient Shipwrightry*. Note the rising and narrowing lines and how they influence the shape of each frame. *Courtesy of the Pepsyian Library, Magdalene College.*

on the one hand, or 45 feet using the 15-foot beam of the *Patience*. Locating the midship frame on the keel is the next step. Mathew Baker stated that the location of the midship frame was 36.2 percent of the keel length, aft of the keel's forward end.[111] So for the *Sparrow-Hawk*, this would be just under 11 feet aft of the keel's forward end. This can be applied for both models.

Hariot gives the angle of the sternpost as 22.5 degrees from vertical,[112] Baker gives it as 70 degrees to the horizontal and the Admiralty Library manuscript gives it between 18 and 20 degrees. Brian Lavery took an average and arrived at 20 degrees for the *Susan Constant*. The letter from Dolliver and Sleeper concerning the *Sparrow-Hawk* describes the rake of her sternpost as being four inches per foot—or for every foot of rise, there are four inches of rake aft.[113] I will therefore use this for the sternpost of the *Sparrow-Hawk*. According to the Admiralty Library manuscript, the height of the sternpost is equal to eight-sevenths of the depth of hold. This would yield a height of sternpost as about seven feet, five inches for the *Sparrow-Hawk*. Above this is the counter, which is given as eleven-tenths of the depth of hold. The transom is a straight line, the angle of which is slightly less than that of the sternpost, which is consistent with Mathew Baker's *Fragments*, Lavery's *Susan Constant* and W.A. Baker's *Mayflower II*.

The next step is to fill in all the frame sections/shapes between the midship frame running both forward and aft to the stem and stern, respectively. These sections are derived in similar fashion to the midship section—in other words, using a sequenced and proportional series of compass arcs and straight lines—and are influenced by two other sets of lines, the rising and narrowing lines. Since Tudor shipbuilding formulas were designed such that a ship could be built using only a few arcs from a compass and a straight edge, the principles governing them had to account for the inevitable tapering of a vessel at either end; this was/is the function of the rising and narrowing lines. The rising lines controlled the angle of the floors or that part of the vessel that "rests on the ground." Since the flat part of a hull bottom on Tudor ships only occurred near the middle and down next to the keel, the rising line used a horizontal and vertical plane as extremes between which the angle of the floor would "rise"—moving from the horizontality of the midship floor to the verticality of both stem and sternpost. I have drafted two sets of rising lines and corresponding hull sections, both using the six-and-a-half-foot depth of hold (version 1). The first set uses proportions by Hariot as interpreted by Brian Lavery; the second uses proportions taken from Mathew Baker's *Fragments*. It is interesting and important to note how sharp the stern area (deadwood) of the *Sparrow-Hawk* actually is; it would

have required quite a bit of hull above this fin-like area to have enough positive buoyancy to allow the vessel to float evenly fore and aft. This great amount of deadwood would tend to favor the higher rising line at the stern as advocated by Mathew Baker (see figures h and b).

Lavery, citing Harriot, states that the lower rising line is the arc of a big circle and is tangent to the top of the keel at the midship section, the sternpost at the tuck and the stem at the gripe. The height of the tuck is calculated at being five-ninths of the depth of hold. At the stem, Harriot gives the height of the gripe as one-fifth of the height of the tuck. There is a second rising line, which is another arc of a circle, that must pass through the height of the maximum breadth line on the midship section and meet the sternpost at four-thirds of the depth of hold and forward at nine-eighths of the depth of hold. The toptimber, or sheer rising line, is parallel to the upper rising line and is spaced at a distance equal to the depth of hold. The following is a table that describes the two sets of rising lines for the Hariot and Baker versions, as applied to a vessel with a six-foot, six-inch depth of hold:

	SPARROW-HAWK VERSION 1	SPARROW-HAWK VERSION 2
	(Hariot)	(Mathew Baker)
1st rising line:		
Height of the tuck at sternpost	3 feet, 7 inches	4 feet, 9 inches
Height of gripe at stem-	8 inches	1 foot, 1 inch
2nd rising line:		
Sternpost	8 feet, 7 inches	10 feet, 4 inches
Stem	7 feet, 3 inches	8 feet 10 inches

The narrowing lines controlled the amount of taper of the main hull form at the bow and stern, moving both fore and aft from the midship frame. Not surprisingly, both the rising and narrowing lines were derived from (more) arcs of circles. The narrowing lines occur in three places. The first, or lowest, one is a distance from the baseline of half of the half-breadth, meeting the sternpost at the tuck and at the bow, where the lower rising line meets the stem.[114] The upper narrowing line is fixed at the maximum beam amidships, the wing transom aft (top of sternpost); the width of the wing transom is

**Rising lines & Narrowing
lines according to
Mathew Baker**

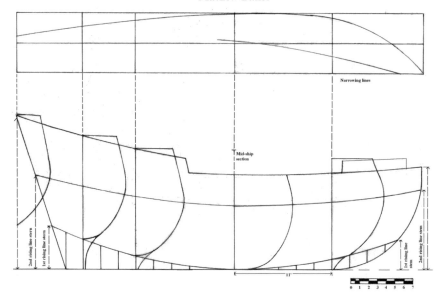

The rising lines for the *Sparrow-Hawk*. *Drawing by author.*

half the ship's maximum beam.[115] To make this extremely simple, the same
arc that was used to derive the midship frame was also used to derive all the
frames between the bow and stern, and the narrowing line controlled the
distance between the arc of a given frame station and the centerline (running
fore and aft from stem to stern). We are fortunate to have a record of the use
of the so-called rising and narrowing lines from Mathew Baker's *Fragments*,
which as mentioned, allow for a proportionate and gradual narrowing or
tapering at either end of the ship. Both the Hariot and Baker narrowing
lines are similar, so one set (Baker's) was used for the drawings of the two sets
of rising lines and sections. What becomes immediately apparent regarding
the existing portion of the *Sparrow-Hawk* is that only a small amount of the
ship remains today relative to the entirety of the hull in 1626.

Suffice it to say that no matter which set of proportions are used to govern
the shape of the hull—be they Mathew Baker's, Hariot's or those in the
Strachey tract—they all basically follow the same general principles and
generate templates for each piece of the hull in a formulaic fashion. It is
interesting to note, however, that when the hull emerged from the sands in the

1860s, many onlookers commented on its unusual shape. Today, we might view this as evidence that the *Sparrow-Hawk* was not an English-designed vessel but rather some foreign style of construction. However, this idea is easily dismissed. People of the 1860s would not have been as familiar with Tudor ships as we are today, thanks to archaeological study and documentation on vessels such as the *Mary Rose* and *Vasa* and the reconstructive hypotheses of W.A. Baker and others concerning this period of ship design.

Interior Arrangement

We know from Bradford that the *Sparrow-Hawk* had a cabin aft, with a door into it. (You will recall Captain Johnston lying on the floor of this room and giving instructions through same door.) Presumably, she had a fireplace of some sort to be able to "burn up all their casks," as Bradford mentioned. We have established that the depth of hold was between six and a half to eight feet and that there must have been enough space below to hold provisions for six weeks at sea, plus the "many Irish servants," farming equipment and other trade goods that Bradford mentioned. The assumption up to this point has been that the *Sparrow-Hawk* had a large open hold in which ballast stones, casks and various goods were carefully stacked, with boards placed on top to create a platform on which the passengers and crew slept. However, this seems like an unworkable solution to the problem, as it would have required pulling up the boards and moving cargo around each time in order to access a new cask —a difficult proposition in a pitching and rolling ship. Furthermore, the "open hold" argument is further weakened by the measurements given in Strachey's account of building the two pinnaces *Deliverance* and *Patience*, both of which describe a "tween decks" height of four and a half feet. It seems that this information was not lost on the designers and builders of the *Godspeed* and *Discovery* at Jamestown, as their interior arrangements for both of these vessels show two decks with a very low "tween decks."

It seems sensible then that *Sparrow-Hawk* followed the example of the *Deliverance*, *Patience*, *Godspeed* and *Discovery* and had two decks. Ballast, some of the casks and various supplies would go below the orlop, or lower deck, and people and things that needed to stay dry would be placed above in the 'tween decks area. Another key piece of information that can be gleaned from Strachey's account is that even smaller pinnaces had a raised forecastle- so perhaps the *Sparrow-Hawk* had a small raised forecastle too (depicted in drawings); this would have been the location of the fireplace.

THE RIG

The rig of the *Sparrow-Hawk* has been the subject of disparate views over time. Bradford refers to her as "a ship," although others like W.A. Baker and H. H. Holly refer to her as a ketch, claiming that Bradford just didn't know the difference between a ketch and a ship. Interestingly, W.A. Baker noted that he felt perhaps the original *Mayflower* was ketch-rigged but then favored a ship rig in his final design for the replica.[116] Importantly, in Bradford's *History of Plimoth Plantation*, there are dozens of references to barks, ketches, shallops, pinnaces and ships, which could mean that he was able to differentiate between different rigs; otherwise, why wouldn't he have simply called all boats and vessels ships? Moreover, the location of the mast step, as documented by Otis and supported by the actual remains of the vessel, supports the conclusion that the mast step was amidships, which would be about the location of the main mast for a ship. There seems to be general agreement that the vessel had a mizzenmast, so the only remaining question is whether or not she had a foremast and bowsprit. I think she did—it would have helped balance the rig. And Otis did mention a large

This page and next: Three images of small merchant vessels of the seventeenth century, all carrying foremasts and all with modest beakheads.

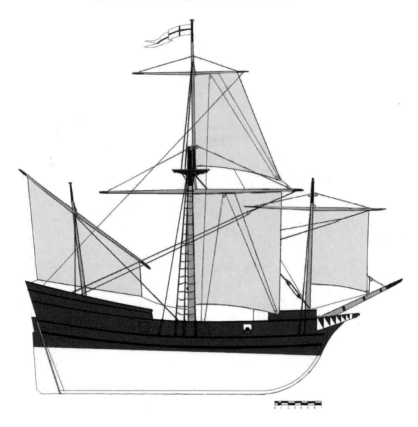

Sail-plan for the *Sparrow-Hawk*. *Drawing by author.*

amount of deadwood at the stem, which could have supported a foremast step. Seventeenth-century artwork tends to support the notion that even smaller vessels had foremasts and bowsprits. Therefore, I propose that the *Sparrow-Hawk* most likely carried a bowsprit, a small foremast (no topmast), a main and main topmast and a small mizzenmast.

W.A. Baker, in computing the lengths of the *Mayflower II*'s masts, used the following formula: length of mainmast in yards equals three-fifths of the sum of the breadth and depth in feet.[117] The bowsprit and foremast are six-sevenths of the mainmast; the mizzenmast is calculated, according to Mainwaring, as one-half the length of the main mast.[118] The main topmast is one-half the length of the lower mast, and the length of the main yard (in yards) is equivalent to one-third the sum of half the keel length plus the maximum beam. The fore and mizzen yards are three-fourths the length of the main yard, and the spritsail yard (although the *Sparrow-Hawk* most likely

did not carry one) is three-fourths the length of the foreyard.[119] Mainwaring also notes that the main topsail yard is three-sevenths the length of the lower yard.[120] To summarize for both versions:

	Sparrow-hawk Version 1 (19.5-foot combined beam & depth)	*Sparrow-hawk* Version 2 (23.5-foot combined beam & depth)
Main mast	35 feet	42 feet, 4 inches
Fore mast	30 feet	36 feet, 3 inches
Bowsprit	30 feet	36 feet, 3 inches
Mizzen mast	17 feet, 6 inches	21 feet, 2 inches
Main topmast	17 feet, 6 inches	21 feet, 2, inches
Main yard	28 feet	30 feet, 5 inches
Fore yard	21 feet	23 feet
Mizzen lateen yard	21 feet	23 feet
Main topsail yard	12 feet	13 feet
Sprit-sail yard	15 feet, 9 inches	17 feet, 3 inches

The masts and spars would have been fashioned from a whole tree, as opposed to being built up from pieces in a larger ship. The bark would have been shaved off using a drawknife or perhaps an adze. Next, all high spots were dubbed off, and the logs were tapered to yield a smooth spar or mast. During the Tudor period, spars and small masts were usually seasoned in a salt pond to keep them from drying out too rapidly and/or rotting. After they were ready, they were taken out and shaped to final dimensions using planes, adzes and drawknives. A liberal coating of pine tar perhaps mixed with tallow would serve as a protective coating. The masts were then stepped on the waiting hull, standing rigging was set up and spars were fitted. After all appropriate running rigging and tackle was installed, the ship would be ready for sails and all other appurtenances such as anchor cables and anchors, cannons, flags, etc.

9

THE TUDOR
SHIPBUILDER'S ART

The methodology used in the construction of seventeenth-century ships is an area for which there is scant information. There is one interesting engraving that exists; however, although a fascinating image, in terms of actually framing and building a vessel, it serves more to confuse than elucidate. There is a passage in John Smith's *Sea Grammar* that outlines ship construction in very general terms. There is also William Strachey's description of building two pinnaces in his tract of 1609, which is even more general and lacking in specifics—with the exception that some measurements are given for the two vessels. Smith describes laying the keel:

> *A great tree or more—hewn to the ships burden* [size]*, which is laid on building stocks* [timbers that are place on the ground to accept the keel]. *Next, the stem is scarfed to the keel at the bow, and the sternpost is let in to the keel at the stern. After this has been accomplished and presumably braced so to keep the sternpost and stem plumb, the floors, which have been pre-shaped according to the lofting* [full-sized drawing of key components of a vessel] *for the particular vessel, they are bolted athwart—or perpendicular to the keel. Each of these floors or "ground timbers" features a slight rising curve* [termed "compass"] *at either end—these are termed "rungheads"— which begin to describe the curve of the hull at its lowest point—or nearest to the keel. Through each floor a notch is cut on the outboard side (facing the inside of the planking)—these are called "limber holes" and are meant to allow water to pass from one end of the ship to ultimately end up at the pump.*

The *Sparrow-Hawk* has her limber holes running along the center of each floor. In the early modern period, a rope was passed through these notches and hauled at either end of the vessel, back and forth, to keep them from clogging. The floors were either bolted or trunneled[121] to the keel. The remaining portion of the *Sparrow-Hawk* indicates that the floors were trunneled.

Smith states that after the floors have been secured, a keelson (timber of similar dimensions to the keel) should be bolted down on top of all the floors, thus sandwiching them and making for a very strong structure. Interestingly, *Sparrow-Hawk*'s keelson (eight by ten inches) is much larger than her keel (six by eight inches), which could mean one of two things: she may have had another timber fastened to the bottom of her keel (a "shoe") or much of the longitudinal strength of the "backbone" was provided by the keelson, not the keel. Few of the period texts describe precisely how the ship proceeds from this point forward, but they are clear that the boat was finished as work progressed from the ground up, or was completed in stages. This is in contrast to nineteenth-century building methods where whole frames (resembling the ribs of a whale or some other creature) were erected in their entirety on the keel and then planked—frame first construction. The Greeks, Romans and Venetians practiced shell first construction, which is to say: the planking was fitted and joined first, with the frames or ribs being fitted after the skin of the vessel was in place. Seemingly, the change from shell-first to frame-first construction occurred gradually during the sixteenth and seventeenth centuries, and the method used for building the *Sparrow-Hawk* was probably a combination of both techniques occurring simultaneously or alternately. For example, after the floors were fitted and secured to the keel, the garboard (or plank next to the keel) would most likely have been fitted (Smith's *Sea Grammar* more or less implies this), and probably a few more planks were fitted to afford a place to which the first futtocks could be fastened. As the first futtock timbers were fastened to the hull planking, they were probably faired and tied together at their extremities by removable ribbands, or strips of wood, that would keep the ends of the timbers aligned while they were being planked. The *Manuscript on Shipbuilding* (circa 1600) mentions a methodology as follows:

> *You must observe when the futticks be set up that you put up a cross paule to his just breadth at every third or fourth bend, being well spiked fast & then measure from the middle line that goeth from ye stem to the* [stern] *post that one side be no further out then the other then shoare them fast...*

Dutch engraving showing a small seventeenth-century boat being constructed. There is little visual documentation on how a vessel was constructed during this period. This image is somewhat whimsical, and certain parts of it do not make sense. However, it does show some interesting methodologies that have survived. For example, in the lower right, we see planking stock that has been crossed to facilitate proper drying/seasoning of the wood. This is still done today. *Courtesy of Plimoth Plantation.*

> *and as you crospaule the futticks so do the toptimbers. Also be sure to put in strong ribbings to your flower* [floor] *timbers & futticks & toptimbers in the midst of their soarfes of the futtick & flower timbers should ever be the strongest ribbings.*[122]

Both *Sea Grammar* and the 1600 *Manuscript on Shipbuilding* describe almost an identical process for installing the floors ("flowers") to the keel, which is to say that the floors were placed on the keel first and not as part of a full frame built near the keel on a flat framing platform—a practice begun in the late seventeenth century that continues to the present. It would seem from the passage above that the strongest ribbings—no doubt the antecedent to the modern ribbands[123]—would have supported the overlap of the floor and futtock joint, and it is unclear what is meant by "soarfes." Either this means

scarf, and therefore the futtocks were in fact joined to the floor, or it simply means an overlap, as we see in the *Sparrow-Hawk*. The fact that the strongest ribbings should be placed at this juncture implies that the joint or overlap was fragile. The 1600 *Manuscript on Shipbuilding* continues by describing the installation of the main wale next.[124] This makes sense, as it would add longitudinal strength to the entire structure and serve to tie the stem to the stern assembly. Interestingly, *Sea Grammar* contains an engraving of a ship of the period, which among other things shows an abundance of wales running fore and aft. Perhaps some of these were the ribbings mentioned in the 1600 *Manuscript on Shipbuilding*. The same would occur inside the ship with its ceiling planking and stringers.

Bear in mind that this was all done using compass (or curved) timbers that came from parts of a tree that suited specific curves and shapes. The innovation of steam-bending timbers had not yet been thought of, although "charring" (placing planks on a bed of wood coals and then dousing them with water) of planking stock was used extensively to soften hull planking to take extreme bends at the bow and stern. Archaeological evidence supports this theory; in fact, some of the *Sparrow-Hawk*'s planking exhibits blackened portions. The application of heat softened the lignin of the wood and allowed it to bend with greater ease.

All the pieces of wood necessary to build the vessel were shaped without the benefit of power tools, much of the work being done with the adze, a tool invented by the Egyptians. Holes through the planking into the frames to receive the trunnels were bored with an auger. Each hole required countless revolutions made by aching arms in tough English oak. Planks were sawed off the log in saw pits, which were quite literally pits in the ground over which sawyers placed the log, with a sawyer on the top and bottom of a huge pit saw. The person below received an unending shower of wood dust until the cut was completed. Another more people-friendly method involved a pair of large sawhorses, upon which the log was placed so that at least the sawyer below would have ambient breezes to blow some of the sawdust away. Each plank was shaped to fit a specific place on the hull and then installed using iron spikes and trunnels. According to *Sea Grammar*, this work proceeded from the keel up, and the vessel was finished—including decks—as the sides of the vessel approached the sheer or top of the hull.

Undoubtedly, the planking of the bluff bows would have required the planking stock to be "charred" to soften it and allow for easier bending. This is alluded to in Strachey's account of the building of two pinnaces, as he mentions that oak was used to plank the bows (which, using the

aforementioned "charring," bends well) and that the cedar with which the remainder of the hull was planked was too brittle.[125]

The bow of the *Sparrow-Hawk* may or may not have had a beakhead. These were clearly in fashion at the time and served to break up waves before the bow plunged into them. It was also a logical place to attach the tacks for the fore course. Almost all period images of merchant ships include beakheads of varying sizes. After planking, the vessel would have been caulked using oakum. This material can still be purchased and has the advantage of being inexpensive and, when subjected to water, expands to ten times its volume. Strachey mentioned that they used hemp cables, scavenged from the *Sea Venture*, for caulking the pinnaces. The rope was then torn into pieces to make oakum, which was in turn driven into the seams using a caulking iron and mallet. After caulking, "graving" would have been next, according to *Sea Grammar*. This involved treating the underwater body of the vessel with a mixture of tallow, soap and brimstone—or train oil, rosin and brimstone boiled together.[126]

A beakhead. These became widely used during the latter part of the sixteenth century to break up heavy seas. This particular beakhead, or headrail, is from the Swedish ship *Vasa*, which sank in 1628.

Taking all these factors into consideration yields a solemn appreciation for a craft/art that was the cutting-edge technology of its day. Relatively recently, and fortunately for all those who appreciate history, the advent of many Tudor replicas, such as the *Susan Constant, Discovery, Godspeed* and, of course, *Mayflower II*, have sparked a revival of interest and practice in understanding these vessels. The finished hull of the *Sparrow-Hawk* would have contained a depth of hold of between six and a half and eight feet, and there may have been deck about four or four and a half feet below the main (spar) deck. Strachey's tract mentions a "tween decks" of four and a half feet for a vessel with a forty-foot keel[127] (the *Sparrow-Hawk*'s was close to thirty). Also included in the description by Strachey is mention of a steerage of about six feet high and five feet long, which is where the whipstaff and compass would have been found. Bradford's tract stated that the *Sparrow-Hawk* had a cabin and a door, thus lending credence to the idea that there was an aft cabin with headroom enough for a man to stand. As the deadwood portion of the existing hull leaves no room for the base of a cabin, we must conclude that the *Sparrow-Hawk* would have widened outward and upward significantly to afford enough space for a cabin and steerage compartment. This in turn would have yielded the higher stern castle that was so characteristic of this period. Strachey's tract also mentions a nominal forecastle for the *Deliverance*, which was used to "scour the deck with small shot if at any time we should be boarded by the enemy."[128] So perhaps the *Sparrow-Hawk* may have had a nominal forecastle as well.

The resultant hull would have looked something like the ship depicted on page 88. Importantly, all the etchings and paintings of the period show ships and smaller vessels with high stern castles—a national trend in shipbuilding in England and Europe. In larger vessels, this portion of the ship served as a foundation on which richly carved, painted and gilded ornamentation was applied. During Alan Villiers' epic crossing of the Atlantic in the *Mayflower II*, he noted that the high sterncastle acted like a storm staysail or weathervane in that it kept the bow of the vessel pointed into the wind during gales or severe weather. It is also interesting to note that while monarchs of the period craved and supported such soaring sterncastles and decorations, information derived from experience in the Atlantic world dictated just the opposite. When John Hawkins returned from his epic quest in the West Indies in the mid-1570s, he did so with a crusader's conviction to rebuild the English fleet to make it more "Weatherly" and seaworthy. Hawkins experienced a fierce storm off Florida's panhandle during which he "cut down all the upper works" to ease the ship's straining during this storm. The resultant

"race-built galleons" that Hawkins advocated were much more functional and reflected much of what he learned about what worked and what didn't during his travels in the Atlantic world. Importantly, Hawkins's innovations contributed to a remade English fleet, which was victorious over the Spanish Armada during the epic clash of 1588. This victory did much to contribute to the ethos that Britain's salvation and longevity depended on its mastery of the sea.

CONCLUSIONS AND CONTEXT

The enigmatic remains of the *Sparrow-Hawk*, or whatever she was originally called, beckon us to consider much. What did this vessel actually look like? Who sailed on her, and what were they really like? How did this particular faction fit into early colonial history, especially as perceived almost four hundred years later? Was this group of "untoward people" really representative of the many groups of people coming over during the Great Migration of the 1620s and '30s? What can we learn from her tired old bones about Tudor shipbuilding?

I believe I have tried to give a sense of what she might have looked like. Really, no one can ever be completely sure, as there are so many variables that could have affected the final appearance of the vessel. As for who sailed on her, Sibsey, Fells and Johnston we know well, but who the "many Irish servants" might have been is anyone's guess. What can be gleaned from this group is an ethnic hierarchy in microcosm for England, Scotland and Ireland during this period. English nobility was exemplified by Fells and Sibsey. Johnston was a Scot, and then, of course, there were the many Irish servants.

England regarded the Irish during this period as somewhat "uncivilized," which resulted in its colonial efforts in Ulster and Munster. Edmund Spenser referred to the Irish as being "savage" as early as 1515. It is a small leap to suggest that the English viewed the native people of America in similar terms; in fact, the colonial projects in Ireland were exactly where England cut its ideological teeth concerning colonization.

It is difficult to comment on the character of people we know so little about. However, a few traits must have been present in Fells and Sibsey. Undoubtedly, they were robust individuals who dared to dream big. Sibsey, we know, was a successful planter and politician and was reasonably pious. After his epic sea voyage in the tiny *Sparrow-Hawk*, we know that Fells wanted a girlfriend and got one. It would seem he continued his trading voyages between Virginia and at least Ireland, as mentioned earlier.

When we think of the early seventeenth century today, it is easy to let our thoughts become polarized between distinct sensibilities and traits that characterized Jamestown and Plymouth—e.g. the slave-ridden South and the pious North. However, if there is something meaningful to be learned from the voyage of the *Sparrow-Hawk*, it is that these lines of demarcation seemingly did not exist then. It is true that Bradford kicked the *Sparrow-Hawk*'s passengers out of Plymouth for being "untoward" and "rowdy"; however, Bradford also admitted that there were well-behaved people among them. Moreover, the Separatists were a radicalized group of exiles themselves, intolerant of the religion that most of England accepted at the conclusion of the Reformation. Is it any wonder that those who may have practiced a more moderate variety of Protestantism might have been considered misfits in the context of the Plymouth colony? Edward Channing commented during the first quarter of the twentieth century:

> *Historical writers have been altogether too prone to draw a hard and fast line of demarcation between the settlers of the Southern colonies and those who founded the Plymouth Colony and Virginia and the colonies north of the fortieth parallel. For instance, it is sometimes said that the Northern colonists came to the New World for conscience sake, and the Southern planters sought wealth alone; but no such generalization can truthfully be made. Moreover, it is oftentimes the custom to point out some mysterious difference between the Virginian and the New Englander, which can be expressed by the words "cavalier" and "Puritan," the latter term, when thus used, signifying a social condition below that of the cavalier. No such characterization is possible.*[129]

Also, it is important to note in reference to the aforementioned ethos of North versus South that both the Pilgrims and those on the *Sparrow-Hawk* were originally bound for Virginia, not Massachusetts. Sir John Pory, secretary of the Virginia Colony, visited Plymouth in 1622 and stated flatly that the *Mayflower*'s "voyage was intended for Virginia" and that she carried

letters of introduction from Sir Edwin Sandys and John Ferrar, treasurer and secretary of the Virginia Company, to Governor Sir George Yeardley of the Colony, "that he should give them the best advice he could for trading in Hudson's River."[130] The majority of those of the Massachusetts Bay Company who settled Boston and its surrounds were far more moderate, and our little band from the *Sparrow-Hawk* may have just as easily have settled in Boston as Virginia. After 1627, not a year went by in which vessels bound to or from Virginia didn't visit Plymouth, indicating a robust and regular interaction between the two colonies.[131] Perhaps the voyage of the *Sparrow-Hawk* helped this acculturation in some humble way. In addition, seventeenth-century port books indicate that the majority of colonists crossing the Atlantic during the Great Migration did so in smaller vessels such as the *Sparrow-Hawk*, as opposed to larger vessels like the *Mayflower*, *Susan Constant* and *Sea Venture*. Finally, Samuel Eliot Morison, writing about the *Sparrow-Hawk* in the 1950s, made the following comment:

> *I wish that everyone who visits Plymouth would take a good look at this maritime relic* [Sparrow-Hawk], *which to me is more precious than the famous Rock because of its human associations. Here is clear, irrefutable evidence of the tiny vessels in which the pioneers of Virginia and New England crossed the "wild and raging ocean," and of the hardships they endured. Here is a symbol of that unity between all Englishmen, whatever their creed, in the reign of Charles I, and of the Christian charity that they extended to one another in time of need. I would that a replica of the* Sparrow-Hawk's *rude frames and timbers might be placed in the hall of the Virginia Historical Society.*[132]

Morison suggested that two short statements accompany the abovementioned replica, one by Bradford and the other a poem I found particularly fitting, penned in 1610 by Robert Rich titled "Newes from Virginia," in which Lord de la Warr says:

> *Be not dismayed at all,*
> *For scandall cannot doe us wrong,*
> *God will not let us fall.*
> *Let England knowe our willingnesse,*
> *For that our worke is good,*
> *Wee hope to plant a nation,*
> *Where none before hath stood.*[133]

In conclusion, the provocative old bones of the remains of the *Sparrow-Hawk* excite our imagination and curiosity and deepen our appreciation for those who founded this country. What can they tell us about Tudor shipbuilding? I have tried to give a portrait of the challenges facing these ships and those who sailed on them. Were the ships up to the challenge? It would seem so, although in some cases, just barely, and in others, clearly not. Gazing upon the time-worn yet stout timbers of this, the oldest extant shipwreck in America, one can trace the evolution of shipbuilding in microcosm. Here is proof of the influence of the Mediterranean, of the Atlantic experience and the lessons learned by Hawkins and others. Imbuing these timbers is the ineluctable ethos of westward expansionism; like the Conestoga wagons that would creak and groan their way westward to forge a nation, so did ships like the *Sparrow-Hawk* creak and groan their way across the stormy fetches of the North Atlantic.

The ships might have fared better if they had not made such crossings, but the indomitable spirit of these early adventurers pushed their crews and their ships to their limits to reach what they hoped would be a better life. Without their courage, determination and, yes, these tiny ships, America would never have been born.

Appendix A

WILLIAM BRADFORD ON THE WRECK OF THE *SPARROW-HAWK*

Illiam Bradford writes of the 1626 wreck of the *Sparrow-Hawk*:

Ther was a ship, with many passengers in her and sundrie goods, bound for Virginia. They had lost themselves at sea, either by ye insufficiencie of ye maister, or his ilnes; for he was sick & lame of ye scurvie, so that he could but lye in ye cabin dore, & give direction; and it should seeme was badly assisted either wth mate or mariners; or else ye fear and unrulines of ye passengers were such, as they made them stear a course betweene ye southwest & ye norwest, that they might fall with some land, what soever it was they cared not. For they had been 6. weeks at sea, and had no water, nor beere, nor any woode left, but had burnt upall their emptie caske; only one of ye company had a hogshead of wine or 2. which was allso allmost spente, so as they feared they should be starved at sea, or consumed with diseases, which made them rune this desperate course. But it plased God that though they came so neare ye shoulds of Cap-Codd or else ran stumbling over them in ye night, they knew not how, they came right before a small blind harbore, that lyes about ye midle of Manamoyake Bay, to ye southward of Cap-Codd, with a small gale of wind; and about highwater toucht upon a barr of sand that lyes before it, but had no hurte, ye sea being smoth; so they laid out an anchore. But towrds the eveing the wind sprunge up at sea, and was so rough, as broake their cable, & beat them over the barr into ye harbor, wher they saved their lives & goods, though much were hurte with sale water; for wth beating they had sprunt ye but end of a planke or too,

& beat out ther occome; but they were soone over, and ran on a drie flate within the harbor, close by a beach; so at low water they gatt out their goods on drie shore, and dried those that were wette, and saved most of their things without any great loss; neither was ye ship much hurt, but shee might be mended, and made servisable againe. But though they were not a little glad that they had thus saved their lives, yet when they had a litle refreshed them selves, and begane to thinke on their condition, not knowing wher they were, nor what they should doe, they begane to be strucken with sadnes. But shortly after they saw some Indians come to them in canows, which made them stand upon their gard. But when they heard some of ye Indeans speake English unto them, they were not a litle revived, especially when they heard them demand if they were the Gove'r of Plimoths men, or freinds; and yt they would bring them to ye English houses, of carry their letters.

They feasted these Indeans, and gave them many giftes; and sente 2. men and a letter with them to ye Gove'r, and did intreat him to send a boat unto them, with some pitch, & occume, and spiks, wth divers other necessaries for ye mending of ther ship [which was recoverable]. *Allso they besought him to help them with some corne and sundrie other things they wanted, to enable them to make their viage to Virginia; and they should be much bound to him, and would make satisfaction for any thing they had, in any comodities they had abord. After ye Gov'r was well informed by ye messengers of their condition, he caused a boate to be made ready, and such things to be provided as they write for; and because others were abroad upon trading, and such other affairs, as had been fitte to send unto them, he went him selfe, & allso carried some trading comodities, to buy them corne of ye Indeans. It was no season of ye year to goe withoute ye Cape, but understanding wher ye ship lay, he went into ye bottom of ye bay, on ye inside, and put into a crick called Naumskachett, wher it is not much above 2. mile over land to ye bay wher they were, wher he had ye Indeans ready to cary over any thing to them. Of his arrivall they were very glad, and received the things to mend ther ship, & other necessaries. Allso he bought them as much corne as they would have; and wheras someof their sea-men were rune away amonge the Indeans, he procured their returne to ye ship, and so left them well furnished and contented, being very thankfull for ye curtesies they receaved. But after the Gove'r thus left them, he went into some other harbors ther aboute and loaded his boat with corne, which he traded, and so went home. But he had not been at home many days, but he had notice from them, that by the violence of a great storme, and ye bad morring of their ship (after she was mended) she was put a shore, and so beatten and shaken as she was now wholy unfitte*

to goe to sea. *And so their request was that they might have leave to repaire to them, and soujourne with them, till they could have means to convey them selves to Virginia; and that they might have means to trasport their goods, and they would pay for ye same, or any thing els wher with ye plantation should releeve them. Considering their distres, their requests were granted, and all helpfullnes done unto them; their goods transported, and them selves & goods sheltered in their houses as well as they could.*

The cheefe amongst these people was one Mr. Fells and Mr. Sibsie, which had many servants belonging unto them, many of them being irish. Some other ther were yt had a servante or 2. a peece; but ye most were servants, and such as were ingaged to the former persons, who allso had ye most goods. Affter they were hither come, and some thing setled, the maisters desired some ground to imploye ther servants upon; seeing it was like to be ye latter end of ye year before they could have passage for virginia, and they had now ye winter before them; they might clear some ground, and plant a crope (seeing they had tools, & necessaries for ye same) to help to bear their charge, and keep their servants in imployment; and if they had oppertunitie to departe before the same was ripe, they would sell it on ye ground. So they had ground appointed them in convenient places, and Fells & some other of them raised a great deall of corne, which they sould at their departure. Ths Fells, amongst his other servants, had a maid servante which kept his house & did his household affairs, and by the intimation of some that belonged unto him, he was suspected to keep her, as his concubine; and both of them were examined ther upon, but nothing could be proved, and they stood upon their justification; so with admonition they were dismiste. But afterward it appeard she was with child, so he gott a small boat, & ran away with her, for fear of punishmente. First he went to Cap-Anne, and after into ye bay of ye Massachussets, but could get no passage, and had like to have been cast away; and was forst to come againe and submite him selfe; but they pact him away & those that belonged unto him by the first oppertunitie, and dismiste all the rest as soone as could, being many untoward people amongst them; although ther were allso some that caried them selves very orderly all ye time they stayed. And the plantation had some benefite by them, in selling them corne & other provisions of food for cloathing; for they had of diverse kinds, as cloath, perpetuanes, & other stuffs, besids hose, & shoes, and such like comodities as ye planters stood in need of. So they both did good, and received good one from another; and a cuple of barks caried them away at ye later end of somer. And sundrie of them have acknowledged their thankfullnes since from Virginia.

Appendix B

JOHN PORY'S LETTER TO THE EARL OF SOUTHAMPTON

John Pory served for several years as secretary of the Virginia Colony. The following is an excerpt from his account of the Pilgrims. It was in the form of a letter written to the earl of Southampton, one of the most important members of the Virginia Company of London:

> *For whenas your Lordship knows, their voyage was intended for Virginia, being by letters from Sir Edwin Sandys and Mr. Deputy Ferrar recommended to Sir Yeardley, then governor, that he should give them the best advice he could for trading in Hudson's River, whether it were by contrariety of wind, or by the backwardness of their master or pilot, to make (as they thought it) too long a journey, they fell short both of the one and the other, arriving first at that stately harbour called Cape Cod…whence in shallop the Pilot… after some dangerous and almost incurable errors and mistakings, stumbled by accident upon the harbour of Plymouth, where after the Planters had failed of their intention, and the Pilot of his, it pleased Almighty God (who had better provided for them than their own hearts could imagine) to plant them upon the seat of an old town, which divers years before had been abandoned of the Indians.*

WILLIAM STRACHEY'S ACCOUNT OF 1606
Deliverance *and* Patience

Deliverance

Shee was fortie foot by the Keele, and nineteene foot broad at the Beame, six foote floore, her Rake forward was fourteene foot, her Rake aft from the top of her Post (which was twelue foot long) was three foot, shee was eight foot deepe vnder her Beame, betweene her Deckes she was foure foot and an halfe, with a rising of halfe a foot more vnder her fore Castle, of purpose to scowre the Decke with small shot, if at any time wee should bee borded by the Enemie. Shee had a fall of eighteene inches aft, to make her sterage and her great Cabbin the more large: her sterage was fiue foot long, and six foote high, with a close Gallerie right aft, with a window on each side, and two right aft. The most part of her timber was Cedar, which we found to be bad for shipping, for that it is wondrous false inward, and besides it is so spault or brickle, that it will make no good planks, her Beames were all Oke of our ruine ship, and some planks in her Bow of Oke, and the rest as is aforesaid. When she began to swimme (vpon her launching) our Gouernour called her The Deliuerance, *and shee might be some eighty tunnes of burthen.*

40 keel
19 beam
6' floors
Rake forward 14 foot
12' stern post—rake from top of this 3 feet

8' depth of hold
Between her decks 4.5'
with a rising of halfe a foot more under her fore castle, of purpose to scowre
the Decke with small shot, if at any time wee should bee borded by the
Enemie.
Drag of 18" to the keel
80 tons burthen

PATIENCE

About the last of Aprill, Sir George Summers launched his Pinnasse, and
brought her from his building Bay in the Mayne Iland, into the Channuell
where ours did ride, and shee was by the Keele nine and twentie foot: at
the Beame fifteene foot and an halfe: at the Loofe fourteene, at the Transam
nine, and she was eight foot deepe, and drew sixe foote water, and hee called
her the Patience.

29' keel
15' 6"
At the loofe 14'
At the transom 9'
8' deep (6' draft)
36 tons burthen

Appendix D

SEVENTEENTH-CENTURY GLOSSARY

Excerpted from Captain John Smith's Sea Grammar, *1627*

— **A** —

Aft or Abaft: from word the Fore part of the ship, or toward the stern, as the Mast hangs aft, that is towards the stern. How chear ye fore and aft, that is, how fares all your ship's company?

Amain: A word used by a Man of War to his enemy and signifies, Yield.

Strike Amain: That is, Lower your Top-saile.

The Anchor is a peek: that signifies the Anchor is right under the Hawse (or hole) through which the cable belonging to the Anchor is run out.

The Anchor is a Cock-belt: that is, hangs up and down by the Ship's side.

The Anchor is foul: that is, the Cable is got about the fluke.

An Awning: A sail or the like, supported like a canopy over the deck to prevent the scorching heat of the sun in hot climates.

— **B** —

To bale: To lade Water out of the Ships Hold with buckets, or the like.

Trench the ballast: to divide or separate it.

The ballast Shoots: that is, runs over from one side to the other.

To bear with the Land, &c.: To sail toward it.

To bear in: that is, to sail before or with a wind into a Harbour or Channel. A piece of ordnance doth come to bear – that is, lies right with the mark.

Bear up: a term used in conding the ship, when they would have her sail more before the wind.

Bear up round: put her right before the Wind.

To Belaye: to make fast any running rope.

To Bend a Cable: is to make it fast.

A Birth: a convenient space to moor a ship in.

A Bight: any part of a rope between the ends.

The Bilge: the breadth of the place the ship rests on when she is a ground.

The Ship is Bilged: that is, has struck off some of her timber on a rock or anchor, and springs a leak.

A Bittake: that whereon the compass stands.

A Bitter: turn of a Cable about the Bits.

The Bits: two Main square pieces of timber, to which the Cables are fastned when the Ship rides at Anchor.

A Bonnet: an addition to another sail, when they fasten it on, they say, Lace on the Bonnet; and when they take it off, Shake off the Bonnet; it is very rarely fasten'd to any other than the Mizon, Main, Fore-sail, Sprit-sail, and those Sails are called Courses, as Main-course and Bonnet, not Main-sail and Bonnet.

A Boom: a long pole used to spread out the clew of the Studding sail, &c.

Board and Board: a term used when two ships come so near as to touch one another.

To Go Aboard: to go into a ship. To make a board, or board it up is to turn to Windward.

To Break Bulk: to open the Hold, and take out goods thence.

— C —

Careening: is bringing a ship to lye down on one side while they trim and caulk the other.

Caulking: is driving of Ockum, Span-hair, and the like into all the seams of the Ship, to keep out Water.

To Chase: to pursue another ship, and the ship so pursued is called the Chase.

To Cond or Cun: is to direct or guide, and to cun a ship is to direct the person at the helm how to steer her: If the ship goes before the wind, than he who cuns the ship uses these terms to him at helm, Starboard, Larboard, Port, helm amidships. Starboard, is to put the helm Starboard (or right) side, to make the ship go to the Larboard (or left) for the Ship always sails contrary to the helm. In keeping the ship near the wind, these terms are used, Loof, keep your Loof, Fall not off, Veer no more, keep her to, touch the Wind, have a care of the Lee-latch. To make her go more large, they say, ease the helm, no near, bear up. To keep her upon the same point, they use, Steddy, or as

you go, and the like. The Ship goes Lasking, quartering, veering, or Large; are terms of the same signification, viz. that she neither goes by a wind, nor before the wind, but betwixt both.

The Course: is that point of the compass on which the ship sails: also the sails are courses.

Cut the Sail: that is, unfurl it, and let it fall down. A sail is well cut, that is well-fashioned.

— D —

Dead-water: the Eddy-water at the stern of the ship.

To Disembogue: is to go out of the mouth or strait of a gulph.

To disport: is to find out the difference in diameters of metals betwixt the breech and mouth of a piece of ordnance.

The deck is flush fore and aft: that is, is laid from stem to stern without any falls or risings.

— E —

End for end: a term used when a rope runs all out of the block, so it is unreeved; as when a Cable (or Hawser) runs all out at the Hawse, we say, the cable at the Hawse is run out end for end.

— F —

A Fathom: a measure containing six feet.

A Fack: is one Circle of any rope or cable quoil'd up round.

To farthel (or furl) a Sail: is to wrap it up close together, and bind it with little strings called caskets, fast to the yard.

To fish a mast, or yard: is to fasten a piece of timber or plank to the mast or yard to strengthen it, which plank is called a fish.

To lower or strike the flag: is to pull it down upon the Cap. And in fight is a token of yielding; but otherwise of great respect.

To heave out the Flag: is to wrap it about the Staff.

Free the Boat, or Ship: is to bale or pump the water out.

— G —

The Ships Gage: is so many foot as she sinks in the water; or (to speak now like a Sea-man) so many foot of water as she draws.

The Weather Gage: is when one ship has the wind (or is to weather) of another.

A loom Gale: a little wind.

One Ship Gales away from another: in fair weather when there is but little wind that ship which hath most wind and sails fastest is said, to gale away from the other.

To greave a ship: is to bring her to lye dry a ground; to burn off her old filth.

The Ship gripes: that is, turns her head to the wind more than she should.

— **H** —

To Hale: is the same as to pull.

To over Hale: is when a rope is haled too stiff, to hale it the contrary way, thereby to make it more slack.

To hail a Ship: is to call to her company to know whither they are bound, &c. and is done after this manner, Hoa the Ship! Or only Hoa! To which they answer Hoe! Also to salute another Ship, with trumpets or the like, is called hailing.

Fresh the Hawse: a term used when that part of the cable that lies in the hawse is fretted or chafed, and they would have more cable veered out, that another part of it may rest in the hawse. When two cable that come through two several hawses are twisted, the untwisting them is called clearing the hawse. Thwart the hawse, and rides upon the hawse, are terms used when the ship lies thwart or cross, or with her stern just before, another ships hawse. Note, that the hawses are the great holes under the head of the ship, through which the cables run when she lies at anchor.

The Ship heels: that is, inclines more to one side than the other, as she heels to starboard, that is, turns up her larboard side to lie down on starboard.

To Hitch: is to catch hold.

The Hold of a Ship: is that part betwixt the keelson and the lower deck, where all goods, stores, and victuals do lie.

Rummidge the Hold: is used for clearing or removing the goods and things in the hole. Stowing the hold is when they take goods into the hold.

To Hoise: is to hale or lift up, as Hoise the water in, Hoise up the Yards.

Hulling: when a ship is at sea, and she takes in all her sails, she is said to hull.

— **L** —

The Ship Labors: that is, rowls and tumbles much.

Land fall: is a term used, when we expect to see land; as we had a good Land fall, that is made land (or saw land) according to our reckoning.

Land-locked: is when our land lies round about us, so that no point is open to the sea.

Land-to: a ship is said to lie land-to, when she is at so great a distance as only just to discern the land.

To Lash: is to bind, as Lash the fish on to the mast, that is bind it to the mast.

Launch: is to put out, as to Launch a ship; is to put her of the Dock into the water, but it is sometime used in a negative sense, as when a yard is hoisted high enough, they actually call aloud Launch-hoe, that is hoise no more.

To Lay the Land: is to lose sight of it.

The Lee-Shore: is that shore against which the wind blows.

Have a care of the Lee-latch: that is take heed the ship go not too much to Lee-wards.

A Ship lies by the Lee: that is, has all her sails lying flat against the mast and shrouds.

— **M**—

Mizon Sail: hath several words peculiar to it, as set the Mizon, that is, sit the Mizon sail; Change the Mizon, that is, bring the yard to the other side of the mast; Spaek the Mizon, that is, put the yard right up and down by the mast; Spell the Mizon, that is, to let go the sheet and peek it up.

To moor a Ship: is to lay out her Anchors in such a manner as is most convenient for her to ride by safely.

— **N** —

Neap Tides: are the tides when the moon is in the second and last quarter, and they are neither so high, nor so low, nor so swift as the spring tides.

A Ship is beneaped: a term used, when the water does not flow high enough to bring a ship from off the ground, or out of a dock, or over a bar.

— **O** —

The Offing: that is, fromward the shore, or out into the sea; the Ship stands for the Offing, that is, sails from the shore into the sea. When a ship keeps the middle of the channel, and comes not near the shore, she is said to keep in the Offing.

Off-ward: is contrary to the shore; as the stern of a ship lies to the Off-ward, and her head to the shore- ward, that is, her stern lies to the sea, and her head to the shore.

Overset: is turning over, but if a ship turn over on a side, when she is trimming a ground, it is called overthrown.

— P —

To Parcel a seam: is (after the seam is caulked) to lay over it a narrow piece of canvas, and pour thereon hot pitch and tar.

To Pay a seam: is to lay hot pitch and tar on (after caulking) without canvas.

To Ride a Peek: is when the Yards are so ordered, that they seem to make the figure of St. Andrews Cross.

To Purchase: in a ship bears the same sense as draw many times, as the Captain purchases apace, that is, draws in the Cable apace.

— Q —

Quarter Winds: are when the wind comes in abaft the main-mast-shrouds even with the Quarter.

A Quoil: is a Rope or Cable laid up round one Fack over another, and the laying the Fack, is called quoiling.

— R —

A Reach: is the Distance between any two points of land, that lie in a Right-line one from another.

To Reeve: is to put a Rope through a block; and to pull a rope out of a block is called unreeving the rope.

To Ride: when a ship's anchor hold her fast, so that she does not drive with Wind or Tide, she is said to ride at Anchor.

To Ride athwart: is to ride with the ship's side to the tide.

To Ride betwixt Wind and Tide: is when the wind and tide are contrary and have equal strength.

To Ride Hawse-fall: is when in a rough sea the water breaks into the Hawses.

A Road: is any place near the Land where Ships may ride at Anchor, and a ship riding there is called a Roader.

Rowse-in: (that is, Hale in) proper only to the Cable or Hawser, and is used when the Cable or Hawser is slack to make it straight.

— S —

A Sail: Besides its proper signification (as belonging to several yards, from which it takes its various names, as Main-sail, &c.) it signifies also a Ship, as when at sea we descry a ship, we cry out, A Sail! A Sail! Likewise if we speak of a Fleet (or a number of ships together) we say the Fleet consists of 40 or 50 Sail, and not 40 or 50 ships.

To Serve a Rope: is to wind something about it, to keep it from fretting out.

To Seaze: is to make fast or bind.

The Ship seels: that is, when on a sudden she lies down on her side. And tumbles from one side to the other.

The Ship sends: that is, her head or stern falls deep in the trough or hollow of the Sea.

To Settle a deck: is to lay lower.

The Ship is sewed: that is, the water is gone from her.

The Ship shears: that is, goes in and out, and not right forward.

To Sound: is to try with a line or other thing how deep the water is.

The Ship hath spent her masts: that is, her mast have been broke by foul weather; but if a Ship lose her masts in a fight, we say, her masts were shot by the board.

To Splice Ropes: is to untwist two ends of ropes, and then twist them both together, and fasten them with binding a string about them.

The Sail is split: that is, blown to pieces.

The Ship Spooms: that is, goes right before the wind without any sail.

The Bow-sprit Steeves: that is, stands too upright. Steeving is likewise used by Merchants when they stow Cotton or Wool, which being forced in with skrews, they call Steeving their Cotton or Wool.

— **T** —

Tack about: that is, bring the Ship's head about to lie the other way.

Tallee aft the sheats: a term used for haling aft the sheats of the Main or Fore-sail.

A windward Tide: when the Tide runs against the wind.

A Leeward Tide: when the Wind and Tide both go one way.

A Tide gate: where the tide run strong.

To Tide it up: is to go with Tide against the Wind, and when the Tide alters to lie at Anchor till it serve again.

It flows Tide and half Tide—that is, it will be high water sooner by three hours at the shore than in the Offing.

To Tow: is to drag anything after the Ship.

The Traverse: is the Ships way.

— **V** —

To Veer: is to let out; as veer more Rope, veer more sheat.

— **W** —

The Ship is Walt: that is, wants ballast.

To Weather a Ship: is to go to windward of her.

To Wind a Ship: is to bring her head about.

How Winds the Ship: that is, upon what point of the Compass does she lie with her head.

To Would: is to bind ropes about the Mast or the like, to keep on a fish to strengthen it.

— **Y** —

The Ship Yaws: that is, goes in and out, and does not steer steddy.

NOTES

CHAPTER 1

1. Selwood, *Diversity and Difference*, 23.
2. Ibid.
3. Ibid., 35.
4. Sheppard, *London*, 142.
5. Ibid., 194.
6. Ibid., 172.
7. Ibid., 175.
8. Ibid.
9. Ibid., 172.
10. Porter, *London*, 65.
11. Hibert, *London*, 36.
12. Sheppard, *Diversity and Difference*, 200.
13. Ibid.
14. Ibid.
15. Lockyer, *Tudor and Stuart*, 295.
16. Ibid., 297.
17. The Spanish "treasure fleets" sailed from the Caribbean and back to Spain and infused the Spanish economy with large influxes of both gold and silver. This arrangement made England fantastically jealous and led to the state-sanctioned piracy (privateering) that allowed England to break into these existing trade networks during the sixteenth century. The desire

for gold and silver was at the top of the list of every royal charter granted for colonists heading to America. This began the lust for gold that would lie dormant and largely unsatisfied in Americans until 1848.

18. Knapp, "Elizabethan Tobacco," 27.
19. Ibid.
20. Ibid.
21. Crawford, "Consumption of Tobacco," 47.
22. Tobacco indigenous to Virginia.
23. Knapp, "Elizabethan Tobacco," 32.
24. Ibid., 30.
25. Menard, "Phantom Empire," 310.
26. Ibid., 21.
27. Knapp, "Elizabethan Tobacco," 52.
28. Colonial State Papers, "Brief Answer," 69.
29. "Virginia in 1625–26," 369.
30. Colonial State Papers, "Brief Answer," vol. 3, no. 46.
31. "Virginia in 1625–26," 371.
32. Colonial State Papers, "Proclamation Touching Tobacco," 86.
33. Kuppermann, *Jamestown Project*, 306.
34. Colonial Papers, "Brief Answer," vol. 4, no. 1.
35. Victims were mutilated, and some, including Indian rights advocate George Thorpe, were beheaded. Kupperman, *Jamestown Project*, 307.
36. Kupperman, *Jamestown Project*, 295.
37. Smith, *Generall Historie*, 21.
38. Colonial State Papers, "Proclamation Touching Tobacco," 83.
39. Ibid., 86.
40. Wilcoxen, *Dutch Trade*, 19.
41. Ibid.
42. Ibid.
43. Ibid.
44. Ibid., 20.
45. Kupp, "Dutch Notorial Acts," 654.
46. Ibid.

CHAPTER 2

47. Knapp, "Elizabethan Tobacco," 44.
48. Otis, *Discovery of Ancient Ship*.

49. There is a letter written in the 1960s by the Orleans town historian claiming that the wreck was used as a victualling ship for the English fleet, which fought against the Spanish Armada in 1588. I have been unable to verify this claim from the PRO in England or any texts published on the Armada.

50. Barbour, "Dutch and English Merchant Shipping," 261.

51. Ibid.

52. Bradford refers to the vessel as a ship (see appendix A).

53. Letter by Dolliver and Sleeper found in *Loss Sparrow-Hawk*, p. 8.

54. Hakluyt, *Principal Navigations*, tried to establish a tradition of British seafaring dating back to the time of King Arthur. Hakluyt helped to craft the idea that seafaring (preeminence) had always been a part of British history and ethos—not merely something that evolved during the reign of Henry VIII through Elizabeth I.

55. Knapp, "Elizabethan Tobacco," 33.

56. Oppenheim, "Royal Navy," 473.

57. Blansett, "John Smith Maps," 69.

58. John Smith's map of New England was so titled to establish it as an English possession and was also in response to other regions that felt the grip of European hegemony, such as New France or New Netherlands.

59. Blansett, "John Smith Maps," 72–73.

60. Raleigh, *English Voyages*, 155.

61. Shakespeare, *The Tempest.*

62. Ibid, 475.

63. Canny, *Origins*, p. 27.

64. Smith, *Sea Grammar*, 65–66.

65. Oppenheim, "Royal Navy," 484.

66. Ibid., 470.

67. Ibid., 493.

Chapter 3

68. Charleton, *Second* Mayflower, 128.

69. Ibid., 123.

70. Bradford, *History of Plimoth*, 377.

71. Charleton, *Second* Mayflower, 128.

72. Strachey, *Voyage to Virginia*, 6.

73. Ibid., 10–11.

CHAPTER 4

74. Presently called Pleasant Bay.
75. Cornerstone Project.
76. Bradford, *History of Plimoth*, 379.
77. Morison, "Plymouth Colony," 148.

CHAPTER 5

78. Bradford, *History of Plimoth*.
79. Ransome, "'Shipt for Virginia,'" 448–49.
80. Minutes of the Council of Virginia, 118.
81. Virginia State Land Office, 453 (Reel 1).
82. Ibid., 159 (Reel 2).
83. Carrington, "Colonial Churches," 142.
84. Ibid., 143.
85. Ibid., 142–43.
86. Ibid., 143; Lower Norfolk County Minute Book, 1637–46, A, 8.
87. Ibid.
88. Carrington, "Colonial Churches," 146.
89. Ibid., 146–47.
90. Hening *Statutes at Large*, 178–179.

CHAPTER 6

91. Carpenter, *Early Encounters*, 102
92. Otis, *Discovery of an Ancient Ship*, 6.
93. Rule, *The* Mary Rose.
94. This can be clearly seen in the remains of the Greek Kyrenian shipwreck that was recovered (see appendix D).
95. During the clipper ship era of the mid- to late nineteenth century, iron strapping was used to bind orlop deck beams to stanchions resting on keel and supporting the same; in a seaway, compression on the hull was causing these beams to lift upwards at the midpoint. It also should be noted that the clipper ships represented the zenith of wooden ship design and construction. Rotten timber would support the general trend that many Tudor ships were still being used well after their intended lifespans.

96. Bradford, *History of Plimoth*, 119.
97. Strachey, *Voyage to Virginia*, 8–9.
98. Ibid., 8.
99. Mason, "Atlantic Crossing," 38–39.
100. Most notably, John Hawkins.
101. Oppenheim, "Royal Navy," 470.

CHAPTER 7

102. *Proceedings of the Massachusetts Historical Society*, 217.
103. Ibid., 221.
104. Ibid.

CHAPTER 8

105 Lavery, *Colonial Merchantman*, 10.
106. Ibid.
107. Baker, *New* Mayflower, 75–76.
108. Strachey, *Voyage to Virginia*, 58.
109. W.A. Baker used Mathew Baker's *Fragments of Ancient Shipwrightry* as a basis for this process.
110. Smith, *Sea Grammar*, 4.
111. Baker, *New* Mayflower, 79–80.
112. Lavery, *Colonial Merchantman*, 10.
113. *Loss of Ancient Ship*, 8–9.
114. Lavery, *Colonial Merchantman*, 14.
115. Ibid.
116. Baker, *New* Mayflower, 103.
117. Ibid., 106.
118. Ibid.
119. Ibid.
120. Ibid.

CHAPTER 9

121. "Trunnel" is a term that represents slang for treenail. These were usually made from seasoned locust and resembled pegs; they were often notched at either end to receive a wedge that, when driven home, would flare the end of the peg, thus preventing it from losing its hold.

122. Barker, *Mariner's Mirror*, 22.

123. Ribbands are merely straight-grained strips of wood that are temporarily attached to the frames. However, the 1600 *Manuscript of Shipbuilding* does not indicate whether or not these timbers are temporary.

124. A wale is merely a thick strip of wood that is fastened directly to the frames; in between them the hull is planked. The main wale serves a variety of functions. First, it ties the frames together fore and aft into the stem and stern. Second, it serves as a rubbing strake to protect the hull from docks and other vessels. Third, as posited by this text, it may have actually aided in assembling the ship in Tudor fashion.

125. Strachey, *Voyage to Virginia*, 56–57.

126. Smith, *Sea Grammar*, 13.

127. Strachey, *Voyage to Virginia*, 56–57.

128. Ibid., 56.

CONCLUSIONS AND CONTEXT

129. Morison, "Plymouth Colony," 153.

130. Ibid., 154.

131. Ibid., 163.

132. Ibid., 164.

133. Ibid.

BIBLIOGRAPHY

Baker, Mathew. *Fragments of Ancient Shipwrightry*. N.p., n.d.

Baker, W.A. *Colonial Vessels: Some 17ᵗʰ Century Ship Designs*. Barre, VT: Barre Publishing Co., 1962.

————. *New* Mayflower: *Her Design and Construction*. Barre, VT: Barre Gazette, 1958.

Barbour, Violet. "Dutch and English Merchant Shipping in the Seventeenth Century." *Economic History Review* 2, no. 2 (January 1930).

Barker, Richard. *Mariner's Mirror* 80, no. 1 (February 1994).

Blansett, Lisa. "John Smith Maps, Virginia: Knowledge, Rhetoric and Politics." In *Envisioning an English Empire: Jamestown and the Making of the North Atlantic World*, edited by Robert Appelbaum and John W. Sweet. Philadelphia: University of Pennsylvania Press, 2005.

Bradford, William. *History of Plymouth Plantation, 1606–1646*. Edited by William T. Davis. New York: Charles Scribner's Sons, 1908.

Burrage, Champlin, ed. *John Pory's Lost Description of Plymouth Colony in the Earliest Days of the Pilgrim Fathers*. Boston, 1918.

Canny, Nicolas. *The Origins of Empire*. New York: Oxford University Press, 1988.

Carpenter, Delores B. *Early Encounters: Native Americans and Europeans in New England*. East Lansing: Michigan State University Press, 1994.

Carrington, George. "The Colonial Churches of Norfolk County." *William and Mary Quarterly* 21, no. 2 (April 1941).

Charleton, Warwick. *The Second* Mayflower *Adventure*. Boston: Little, Brown and Company, 1957.

Colonial State Papers. "Brief Answer to the Propositions Touching Tobacco Lately Delivered by the King's Farmers of Customs." CO 1/3, no. 23, vol. 1 (1574–1660).

———. "Proclamation Touching Tobacco." SP 45/10, no. 61, vol. 1 (1574–1660).

Crawford, John. "On the History and Consumption of Tobacco." *Journal of the Statistical Society of London* 16, no. 1 (March 1853): 45–52.

Crothers, William. *The American-Built Clipper Ship.* Camden, ME: International Marine, 1997.

Hakluyt, Richard. *The Principal Navigations, Voyages, Traffiques and Discoveries of the English Nation.* Project Gutenberg, 2006.

Hening, William W. *Statutes at Large of Virginia.* Vol. I. Richmond: Virginia State Library, 1971.

Hibert, Christopher. *London.* London: Longmans, Green & Co., 1969.

Holly, Hobart H. *Sparrow-Hawk.* Boston: Nimrod Press, 1969.

Knapp, Jeffrey. "Elizabethan Tobacco." *Representations* 21 (Winter 1988): 26–66.

Kupp, Jan. "Dutch Notarial Acts Relating to the Tobacco Trade of Virginia, 1608–1653." *William and Mary Quarterly* 30, no. 4 (October 1973): 653–55.

Kuppermann, Karen. *The Jamestown Project.* Cambridge, MA: Belknap Press of Harvard University Press, 2007.

Lavery, Brian. *The Colonial Merchantman Susan Constant 1605.* London: Conway Maritime Press Ltd., 1988.

Lockyer, Roger. *Tudor and Stuart Britain.* London: Pearson Education Limited, 2005.

Loss Sparrow-Hawk, 1626, Remarkable Preservation: Recent Discovery of the Wreck. Boston: Alfred Mudge & Son, 1865.

Mason, George C. "An Atlantic Crossing of the Seventeenth Century." *American Neptune* 11, no. 1. (January 1951).

Menard, Russell R. "Plantation Empire: How Sugar and Tobacco Planters Built Their Industries and Raised an Empire." *Agricultural History* 81, no. 3 (Summer 2007): 309–32.

Minutes of the Council of Virginia.

Morison, Samuel Eliot. "The Plymouth Colony and Virginia." *Virginia Magazine of History and Biography* 62, no. 2 (April 1954).

Oppenheim, M. "The Royal Navy under Charles I." *English Historical Review* 8, no. 31 (July 1893).

Otis, Amos. *An Account of the Discovery of an Ancient Ship on the Eastern Shore of Cape Cod.* N.p., n.d.

Porter, Roy. *London: A Social History.* London: Hamish Hamilton, 1994.

Proceedings of the Massachusetts Historical Society 4 (1882).

Raleigh, Walter. *The English Voyages of the 16ᵗʰ Century*. Glasgow, UK, 1906.

Ransome, David. "'Shipt for Virginia': The Beginnings in 1619–1622 of the Great Migration to the Chesapeake." *Virginia Magazine of History and Biography* 103, no. 4 (October 1995).

Rule, Margaret. *The* Mary Rose*: The Excavation and Raising of Henry VIII's Flagship.* London: Conway Maritime, 1983.

Selwood, Jacob. *Diversity and Difference in Early Modern London.* Surrey, UK: Ashgate Publishing Ltd., 2010.

Shakespeare, William. *The Tempest*. First Folio edition, 1623.

Sheppard, Francis. *London: A History*. Oxford, UK: Oxford University Press, 1998.

Smith, John. *The Generall Historie of Virginia*. N.p., 1626.

———. *A Sea Grammar*. N.p., 1627.

Strachey, William. *A Voyage to Virginia in 1609*. Charlottesville: University Press of Virginia, 1964.

"Virginia in 1625–26." *Virginia Magazine of History and Biography* 15, no. 4 (April 1908).

Virginia State Land Office. Patents 1–42, Reels 1–41. Land Office Patents No. 1, 1623–1643 (vols. 1 & 2).

Wilcoxen, Charlotte. *Dutch Trade and Ceramics in America in the Seventeenth Century.* Albany, NY: Albany Institute of History and Art, 1987.

ABOUT THE AUTHOR

Mark Wilkins is the director and curator of the Atwood House Museum, home of the Chatham Historical Society. He was formerly the director and curator of the Cape Cod Maritime Museum, where in addition to administrative and curatorial duties, he and a small but dedicated band of volunteers built a replica of an 1886 Crosby catboat, the *Sarah*. He has worked for the Smithsonian Institution. Mr. Wilkins lectures on a variety of historical topics on the Cape and the South Shore. He has spent many years researching and developing vessels for which little or no conclusive evidence exists. He uses comparative analyses with vessels of similar periods and configuration as a guide to reconstructing the vessel in question. Many hours are spent in archives, libraries, historical societies and museums ferreting out bits of information that will help lend clarity to what such vessels may have looked like. As a result, he often constructs a detailed model, accompanied by textual summation, including all sources and an overview of the "chain of evidence" to support his conclusions. These have been executed for various maritime museums nationwide. He endeavors to make this process a collaborative effort between historians, curators, independent researchers and boat builders. He also has made several speculative reconstructions of vessels from the seventeenth century and builds historic replicas of full-sized boats.

Visit us at
www.historypress.net